COLOUR-PENCIL
DRAWING

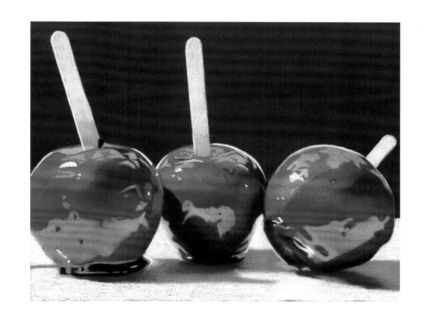

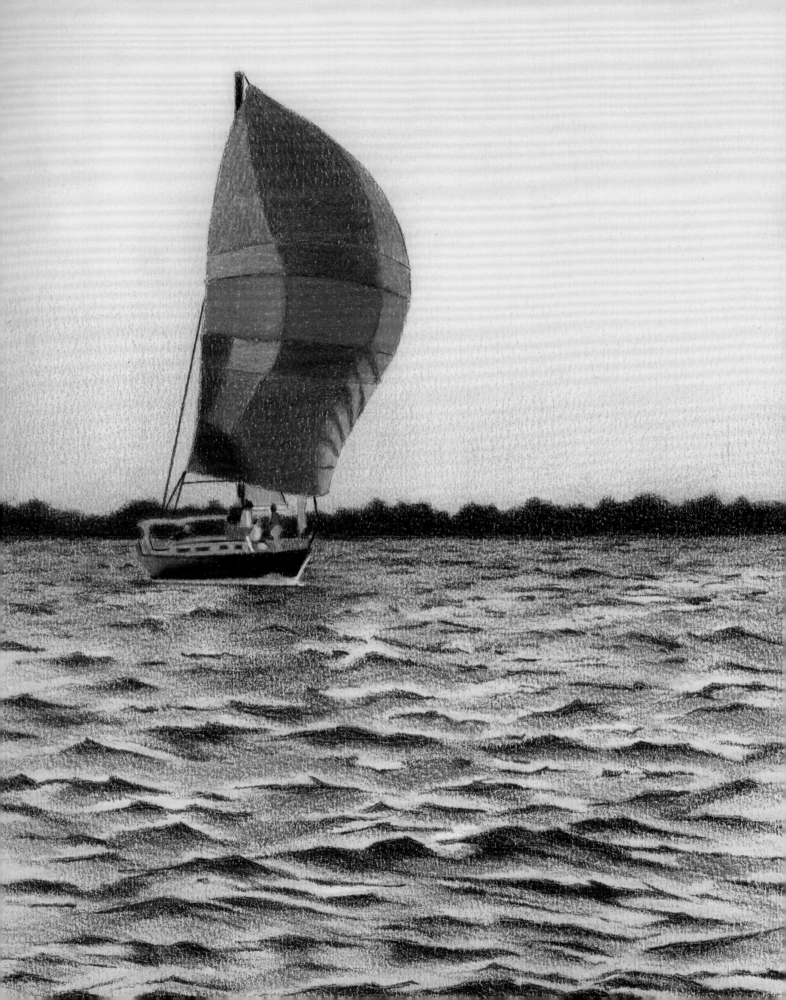

COLOUR-PENCIL DRAWING

TECHNIQUES AND TUTORIALS
FOR THE COMPLETE BEGINNER

KENDRA FERREIRA

First published 2019 by

Guild of Master Craftsman Publications Ltd

Castle Place, 166 High Street, Lewes,

East Sussex, BN7 1XU, UK

Reprinted 2021

ISBN 978 1 78494 530 5

PUBLISHER **Jonathan Bailey**

PRODUCTION MANAGER **Jim Bulley**

COMMISSIONING EDITOR **Dominique Page**

SENIOR PROJECT EDITOR **Sara Harper**

EDITOR **Lisa Morris**

MANAGING ART EDITOR **Gilda Pacitti**

DESIGNER **Wayne Blades**

PHOTOGRAPHY **Kendra Ferreira**

Set in Baskerville Roman

Colour origination by GMC Reprographics

Printed and bound in China

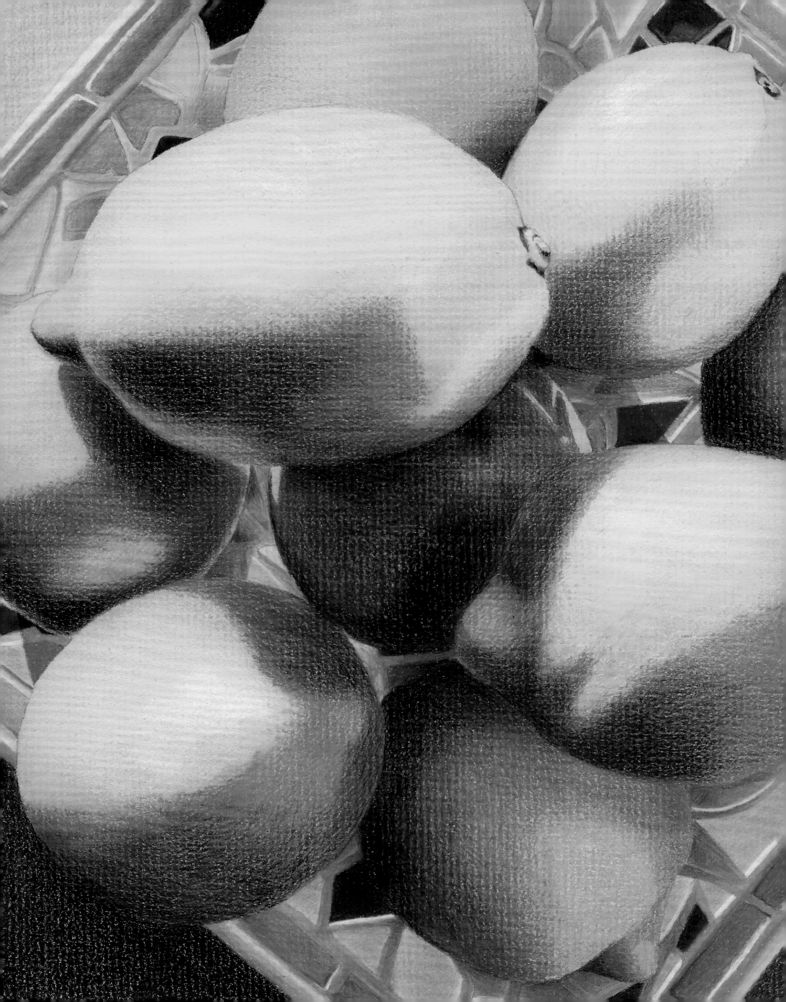

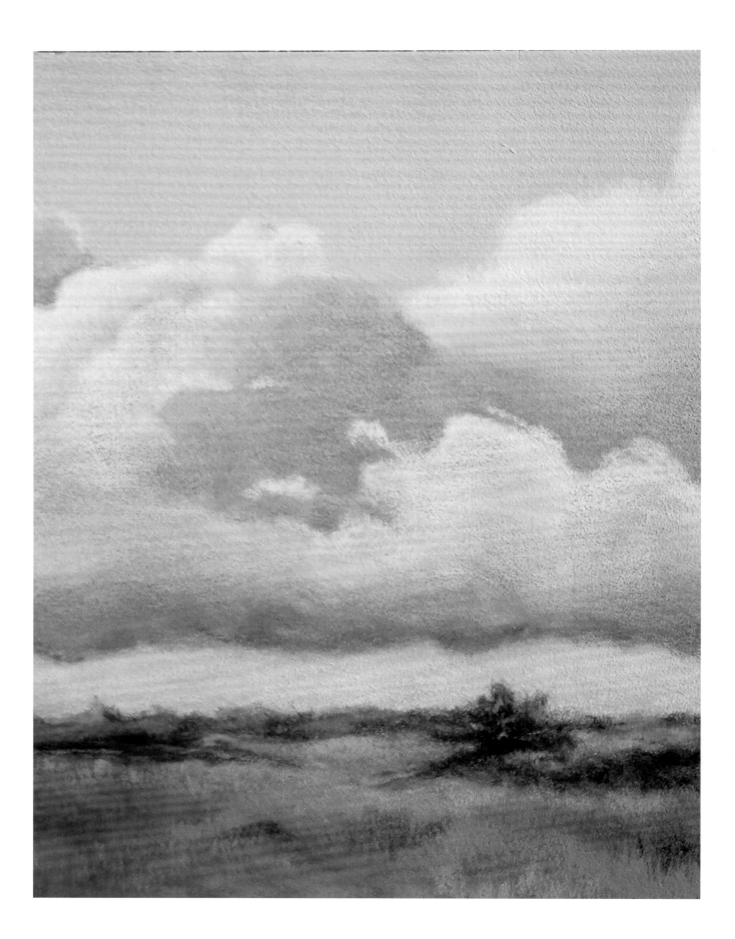

Contents

Introduction

For as long as I can remember, I have always enjoyed drawing and creating art. As a child, I was inspired by my cousin, who was a primary school art teacher. I decided to follow in her footsteps and also become an art teacher some day. My parents enrolled me in art lessons, but it was my secondary school art teacher who really encouraged me to practise and become proficient at drawing. For three years I studied line, shape, texture, value and composition while working only in graphite pencil and black ink.

I discovered coloured pencil in college, when I took a coloured-pencil illustration class. I learned to combine my drawing skills with colour theory and began to experiment and sketch a variety of subjects. College painting classes taught me that any colour could be created by mixing only the primary colours, and I found out how to create rich, dark values without ever using black. I love vibrant colour, and I prefer layering colours on the drawing surface to mixing paint on a palette. The translucency of coloured pencil allows each layer of colour to show through the preceding colours and thus achieves that hint of luminosity in my work.

There are many possibilities for using coloured pencil: it can be used as a preliminary sketching tool for colour studies, for beautiful illustrations or portraits; and it can be mixed with other art mediums for some interesting effects. Coloured pencil is also an easily transported medium and one that can be picked up or put down quickly without the hassles of set-up and clean-up.

I have been teaching art to students of all ages for almost 20 years through various art associations, in my studio or in private lessons. My greatest pleasure as a teacher has been to give students the creative tools and then encourage them to develop their own style. In this book I have put together all the information you need to be able to draw with coloured pencils. We will start by looking at materials and equipment, colour theory, techniques, composition and perspective. Then we will work through a series of step-by-step projects to help you become more proficient with coloured pencils.

You may be familiar with the saying 'The secret of life is in art.' To me, art is my life. Every day I feel an inner drive to create. My greatest satisfactions are inspiring viewers with my art and inspiring my students to see all the possibilities. If you are passionate

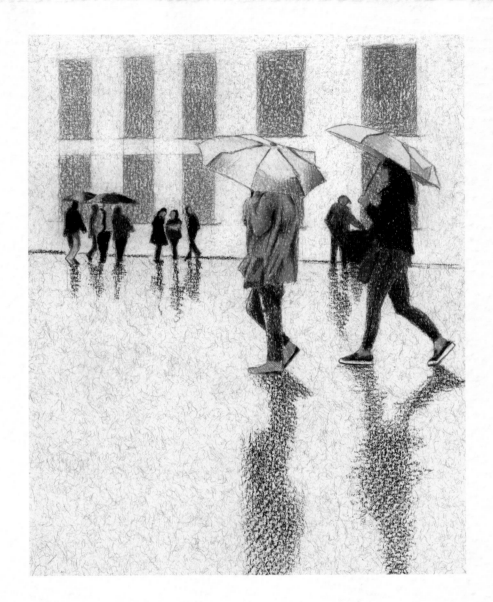

about your drawings, others will be too. Art calls for a lifetime of learning, not only from your own practice but also from looking at the artworks of other artists. I enjoy the process of looking, interpreting and teaching what I see.

So, find some paper, sharpen your pencils and let's start creating!

Kendra

Materials and Equipment

As an art form, drawing with coloured pencils has several benefits: it requires very few materials and equipment, and they are relatively inexpensive; the pencils are easily portable, making them ideal for sketching outdoors or taking away with you; and you can pick them up and put them down at a moment's notice and create some lovely art.

Coloured pencils

Two types of coloured pencils are available: wax-based and water-soluble. Wax-based pencils are composed of colour pigments, wax and other binder ingredients that help the pigment adhere to the paper. All dry pencils are made of wax, but certain brands are considered oil-based because they contain a greater concentration of oil than wax; they are less brittle and a bit harder than wax-based pencils. Both types of coloured pencils can be used together or separately within a drawing. Water-soluble pencils can be applied dry and then blended with water to dissolve the pigment, allowing it to flow like watercolour paint.

There are lots of different brands and qualities of coloured pencils to choose from. Professional-grade pencils have a higher percentage of pigment and a better quality of construction than student-grade pencils. Professional-grade and water-soluble pencils are softer and can be more easily blended and layered.

I try to select pencils that are lightfast, meaning colours won't fade over the years. Lightfast guides rate pigments according to their lightfast qualities and permanence.

Because coloured pencils are layered onto paper, not mixed on a palette, I always suggest that beginners purchase a set of at least 48 colours so they have a wide enough range of

There are many different brands and qualities of coloured pencils to choose from.

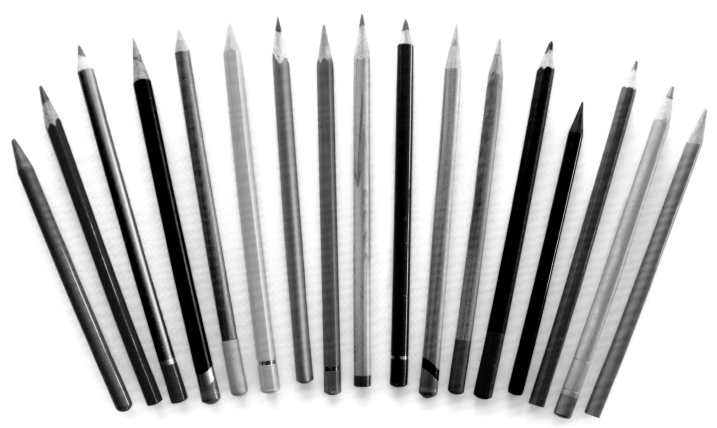

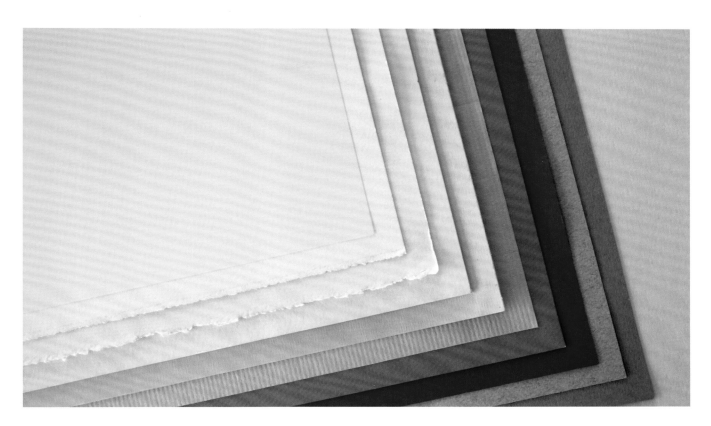

colours. Pencils can also be bought individually, making it cost-effective to add to the set a few at a time.

For the projects in this book, I chose specific colours and brands. However, these are just guidelines – there are many fine brands of pencils, and you are encouraged to use similar colours in any brand you prefer.

Surfaces

The surface grain of a paper is referred to as a finish. The amount of tooth, or texture, to a surface finish will determine how many layers of coloured pencil can be applied. A smooth surface has less tooth so will accept fewer layers of pencil. But rough-textured papers, such as sanded, velour or cold pressed, have more tooth and therefore more layers of pigment can be applied.

Softer pencils layer more easily to smoother surfaces, while harder pencils tend to work better on rough surfaces

because they don't crumble as easily. Some textured papers have a patterned or lined surface that can complement a drawing; experiment to find what surface works the best for your artwork. It is also best to choose archival-quality or pH-neutral papers that won't turn yellow or fade over time. I will talk more about surfaces and the surface colours I've chosen when we come to the individual step-by-step projects.

Sharpeners

A sharp pencil point is easiest to work with when colouring the surface and layering colour. There are many types of pencil sharpeners, including electric, battery-operated and small handheld sharpeners. I most often use an electric sharpener to quickly obtain a nice sharp point. However, battery-operated and handheld sharpeners are also good for sharpening and portable for travel or sketching outside.

Smooth and rough surfaces include sanded papers and boards, drawing papers, watercolour papers, illustration board, velour papers and drafting vellum.

Fixatives

Workable fixative can be used between layers of coloured pencil to hold the colours in place and prevent them from smudging. Fixative can also be used if the surface tooth is becoming saturated: spraying a layer of workable fixative on the drawing will add texture to the surface, thus allowing a few more layers of pencil to be applied.

A second type of fixative is called a final fixative. This comes in a gloss or matte finish and is used to spray the finished drawing and give it a protective coating. I chose a final fixative that contains UV filters, which will protect

my drawings by filtering out harmful ultraviolet rays. Final fixatives will also help something called wax bloom, which is created by some types of coloured pencils. Wax bloom happens when wax rises to the surface and creates a hazy effect on the drawing. This is especially prevalent in heavier applications of pencil or dark-coloured tonal values. If wax bloom occurs, you can just wipe off the haze with a tissue and spray with a final fixative. Always spray fixatives in a well-ventilated area or outdoors.

Block-style erasers (left), including the grey kneaded eraser, and pen-style erasers (centre), can be used to remove colour. The embossing tool (far right) will impress lines to resist colour and a utility knife will lift or scrape off colour.

Erasers

Different types of erasers can be used to make corrections, lighten pencil marks and also as drawing tools to lift out highlights or small areas of colour.

The kneaded eraser (also called a kneaded rubber) is my favourite. It's pliable and can be moulded to any size and shape so you can erase larger areas as well as small details. It also removes pigment without damaging the paper or leaving eraser crumbs on the surface.

A battery-operated eraser that looks like a drawing tool is another favourite option for erasing coloured pencil. It will quickly lift fine lines and areas of colour, and you can also use it as a drawing tool – for example, when creating highlights. Other tools such as the eraser pencil and pen-style mechanical eraser will do the same type of erasing for small areas. Use an erasing shield if you have one, to keep adjacent colours intact.

White vinyl erasers, art gum erasers and other block erasers are good for removing larger areas of colour, but use these tools carefully to avoid smearing pencil or damaging the tooth of the paper. Masking tape and clear tape are also helpful for lifting colour. See page 21 for more information on techniques for erasing and lifting colour.

Utility knife and embossing tool

A utility knife can be used to gently scrape away small areas of pencil colour in order to add highlights, create texture or allow a layer underneath to show. An embossing tool is a pointed instrument that enables you to make an impression in the paper. When adding colour to the drawing, the pencil will skip over the impression, allowing the tone of the paper to remain. This is handy for areas such as strands of hair. See page 21 for more information about using these tools.

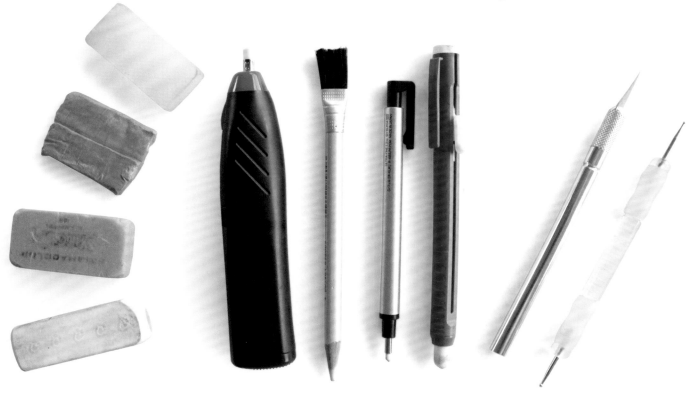

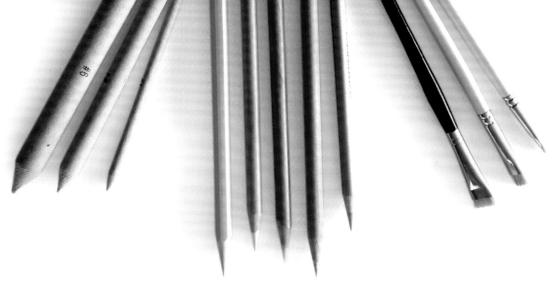

Useful tools for blending and burnishing include (from left to right) paper stumps, colourless blender pencils and small, stiff bristle brushes.

Blending and burnishing tools

Colourless blender pencils, stiff bristle brushes and paper stumps are helpful tools for burnishing coloured pencil. To burnish an area of colour means to press the pencil into the paper, creating a smooth, glossy surface in which no paper texture will show through. The resulting colour will be richer and brighter. To find out more about burnishing, see page 20.

Other useful items

You will need a good smooth drawing board or table on which to work. Some artists work on an easel, but I find it easier to work on an adjustable drawing board propped at an angle so that I don't lean too far forwards and hurt my neck or back. Good lighting is also essential in order to see details, tones and colours. I like to position a desk lamp on my drawing table so that it shines onto my surface.

It is important to keep the surface of the drawing clean. I use a drafting brush or other type of soft brush to sweep away pencil and eraser crumbs – an inexpensive make-up brush will do the trick. You will also need a ruler, and tracing paper to transfer a sketch onto drawing paper.

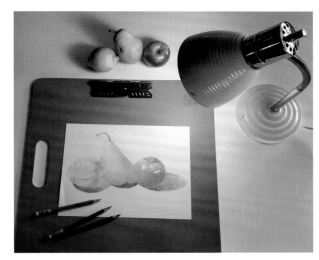

I like to work on a firm drawing surface such as this hardboard, which can be tilted towards you as you draw. A desk lamp is handy to light the subject and the drawing.

Useful items include pencil sharpeners, fixatives, a soft brush, a ruler, and pencil extenders when pencils become too short to hold. Graphite, transfer and tracing papers help transfer a sketch onto good drawing paper.

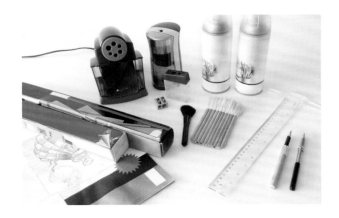

Colour Theory and Tonal Value

Colour theory is a collection of rules and guidelines for using colour in art. Tonal value is the degree of darkness or lightness of a colour or tone, and it is the most important element of a drawing as it provides good structure. Accurately combining colours and understanding how colours and tones relate to one another are essential skills for an artist.

The colour wheel

Every colour in the universe is made up of three primary colours: red, yellow and blue. You can mix every other colour from just these three colours.

Orange, green and violet are secondary colours, and are created by mixing two equal parts of the primary colours: for example, orange is made of red and yellow.

The next set of colours is called the tertiaries. The six tertiary colours are made up of equal parts of one primary and one secondary colour. For instance, blue (primary) plus green (secondary) make a blue-green tertiary.

Together, the three primary, three secondary and six tertiary colours create the colour wheel (see right), a basic tool for combining colours.

Other helpful properties of colour are hues, tints, shades and tones. A colour in its natural state is called local colour or a pure hue. The addition of white to a colour changes that colour to a tint. Adding black changes the colour to a shade and creates a darker value. If both black and white are added, then a tone is created; this creates a greyer version of the colour.

I created this colour wheel using the primary, secondary and tertiary colours. The outer ring is the pure hue, the next is the tint and the third is the shade. The inner circle is each colour combined with its complementary colour directly across the colour wheel. Notice how their dark tones are livelier than the shades.

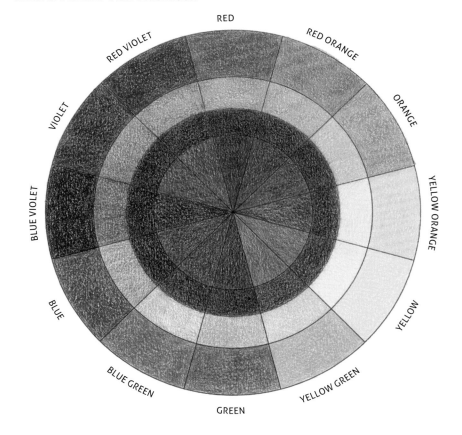

Monochromatic drawing with one colour: red, with black and white.

A

Warm colour scheme with three analogous colours: yellow, orange and red (left).

B

Cool colour scheme with three analogous colours in blue, blue green and green (right).

Colour temperature

Another characteristic of colour is temperature. Colours can be considered warm (**A**) or cool (**B**). Warm colours have red, orange or yellow present and cool colours contain green, blue and violet. However, it is also possible to have a warm blue or a cool red. If a little of a warm colour is mixed with blue, it will become warmer; and the same principles apply if a bit of a cool colour is added to red.

Colour temperature can create a mood as well as depth: warm colours come forwards, while cool colours recede. This is especially helpful when painting objects in the distance. We will learn more about colour temperature in two of the projects: Flower Burst (see page 56), where the overall colour temperature is warm, and Clouds in a Blue Sky (see page 34), where it is cool.

Colour schemes

Colour is all about relationships and creating an overall colour harmony in a drawing. Putting colours together can be exciting, but sometimes it's difficult to know where to begin. Different types of colour formulas can be created using colour, and here are a few to try. One type, the easiest to begin with, is a monochromatic colour scheme (see top, left). This means using variations of one colour only. The colour can be modified by adding black and/or white to create tints, shades and tones, and will vary the intensity of the colour. This type of colour scheme is rather subtle and unified, and is a good way to learn about tones and contrasts.

Complementary colours next to each other and then mixed together (right).

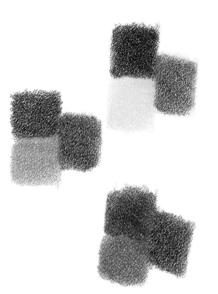

Another type of colour scheme is the analogous colour scheme (see right), which involves using two or three colours that are adjacent to one another on the colour wheel. An example would be green, blue-green and blue, and the intensity of each colour can be varied with black and white. This type of colour scheme works well because the neighbouring colours create a colour harmony.

The strongest colour schemes use complementary colours. Complementary colours are directly across from each other on the colour wheel. For instance, red and green, blue and orange, and yellow and violet are complementary colours. When complementary colours are placed next to each other, they create energy and movement. When a colour is mixed or layered with its complements, the result is a greyer or neutral version of the colour.

Tonal values

One of the most important principles in art is learning and understanding the tonal values on the value scale. I always tell my students that value is more important than colour, as it forms the structure of the artwork. A good range of tonal value helps create space, illusion and atmosphere.

The value scale consists of a series of greys ranging from white to black (see far right) and is used to determine the relationships between light and dark in a scene or subject. We see light on a subject first, but as the subject turns away from the light, or falls into shadow, it becomes darker and creates a range of values. We see form through light and dark in values. Using a full range of values in a drawing will make it visually more exciting; using a limited range of value will create a unified drawing but can lack energy and vitality.

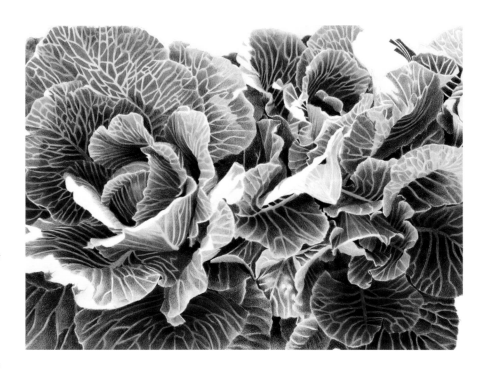

This drawing (above) of colourful cabbages was created by focusing on cool colours in an analogous colour palette.

I created a value scale of ten tonal values ranging from black to white (right). Using these, I then made a small drawing to show how tonal values produce form and structure (below).

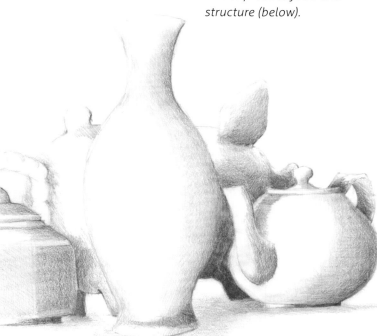

One way to better understand and train your eye to see value would be to shine a light on a white object and study how the light moves across the surface. The object will have the lightest value where the light is closest. Notice how the values darken as the object turns away from the light. The area of your object that is furthest from the light will have the darkest value.

Colour and mood

Not only is colour a way to describe what we see, it can also be manipulated by the artist and used to create a mood or emotional response. A brightly coloured drawing using light tonal values is considered high-key (see right) and will evoke a feeling of happiness or a light, airy feeling. A drawing using darker valued colours is considered low-key (see below) and will evoke feelings of quiet, mystery or drama.

As you work on the projects in this book, you will begin to understand more about colours and values. A colour's value, intensity and temperature are affected by everything around it. A coloured pencil drawing is affected by the colour or tint of the drawing surface, which will alter the value, intensity and temperature of each colour layered on that surface.

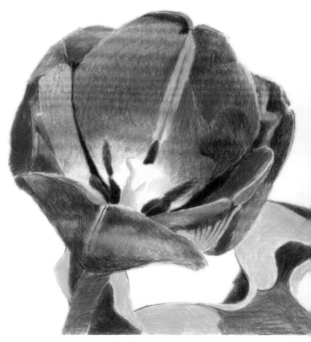

High-key drawing of a brightly coloured tulip: light, airy and consists of vivid colour (right).

Low-key drawing of a dark, dramatic scene drawn on black paper with overall dark tones (below).

Basic Techniques

Varieties of colour and strokes are developed by making marks and layering with coloured pencil. These and other fundamental techniques will help you learn to create your own style of coloured pencil drawing.

Making marks

Pencil strokes can be made in any shape, direction, thickness and strength. With light pressure you can allow the texture of the paper to show through and heavier pressure will fill in the paper's fine indentations, creating a solid appearance.

To build up colour, begin with a sharp point on your coloured pencil and apply short, even strokes to the paper, placing them close together. Press lightly and build colour slowly – if you press too hard and saturate the tooth of the paper, it will be difficult to add more layers of coloured pencil.

Turn the paper and continue to apply more strokes in a cross-hatch form (**A**). Applying strokes in different directions will smooth out the surface and blend any visible directional lines. You can apply different colours in the same manner, working from light to dark and keeping each layer light and blended.

Layering colours

Unlike paints that are mixed on a palette, coloured pencils are mixed on the paper by adding layers of colour (**B**). One colour on the paper can look flat, but two or more colours layered together can create a third colour (**C**)

B

I have layered the five colours on the left, and because the pencil is translucent, the bottom layers show though the top ones (see below).

A

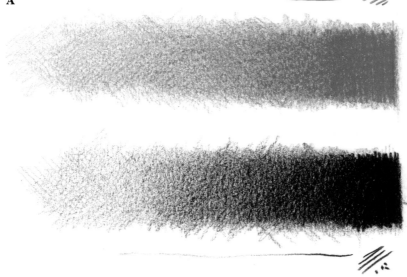

C

The red and blue areas are examples of different types of pressure, ranging from light (left) to heavy (right). Keep your strokes small and close together.

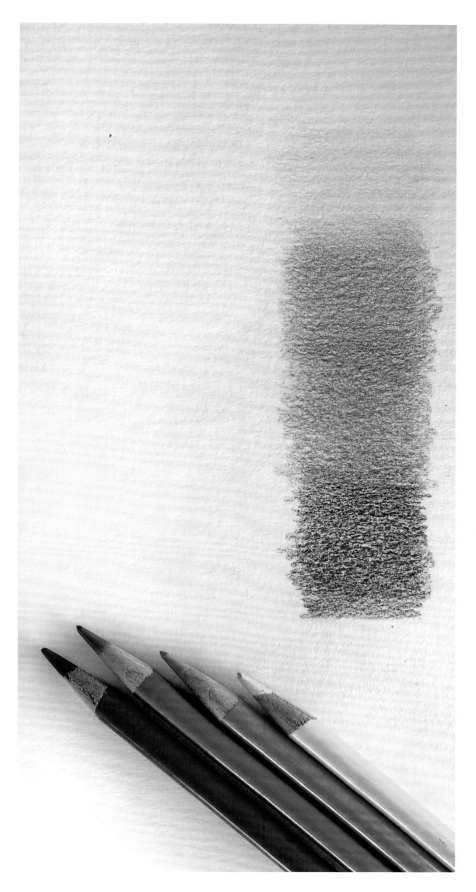

Lay colours side by side and softly blend the edges together by using a light pressure.

and show greater depth and vibrancy. Each layer of colour is influenced by the coloured layers beneath it, as well as the colour or tone of the paper surface you are working on.

Keeping layers light helps make erasing or changing colour easier. If too much pressure is applied in early layers, the tooth of the paper will be saturated, making it difficult to add additional layers. Experiment with different pencil pressures, layering colours and trying different paper surfaces.

As you progress with the layering, you can increase the pressure on the pencil. Continue to blend by cross-hatching and layering until you achieve the colours and tonal values you want to achieve (see page 16).

Optical mixing

Juxtaposing colour, known as optical mixing, means to put two colours side by side, instead of layering them, to allow the viewer's eyes to blend them optically. It's a much quicker method of creating colour and value than layering, and you'll find more information on this in the Flower Burst project on page 56.

Tip
Coloured pencils are translucent so you will be able to see the surface of the paper through the layers.

Burnishing

The technique of burnishing involves applying heavy pressure with a tool in order to blend layers of coloured pencil. This ensures none of the paper texture shows through and creates a shiny, smooth appearance. The effect gives a rich lustre and results in a painterly look. Burnishing can be done with a colourless blender pencil (**A**), small stiff bristle brush (**B**), paper-blending stump (tortillon) or another coloured pencil (**C**). Be sure to use clean pencils, brush and paper stump for each colour burnished. Burnishing will be included in many of the projects in this book.

Painting with pencils

Water can be added to watercolour pencils, and solvent, such as odourless mineral spirits, can be added to wax-based coloured pencils to dissolve the wax. Both techniques allow the pigment to flow like paint and create a rich painterly effect. Adding water to watercolour pencils (**D**) will make the colours transparent and more vibrant. Adding solvent to wax-based coloured pencils will deepen colours and cause them to be more opaque (**E**).

A painterly technique can be helpful when creating an underpainting – a layer of colour or tone that serves as a base foundation for a drawing. It's also helpful for drawing backgrounds or for building colour quickly. Use a small soft brush for applying water or solvent to a layer of coloured pencil and work small areas. Additional layers of pencil can be added over the solvent when dry, or added to watercolour while it is still wet or after it has dried.

Fore more information about using watercolour pencils, see the Nature Study (page 76). For using solvent, see the Toffee Apples project (page 88).

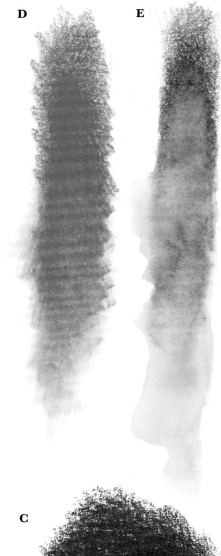

D E

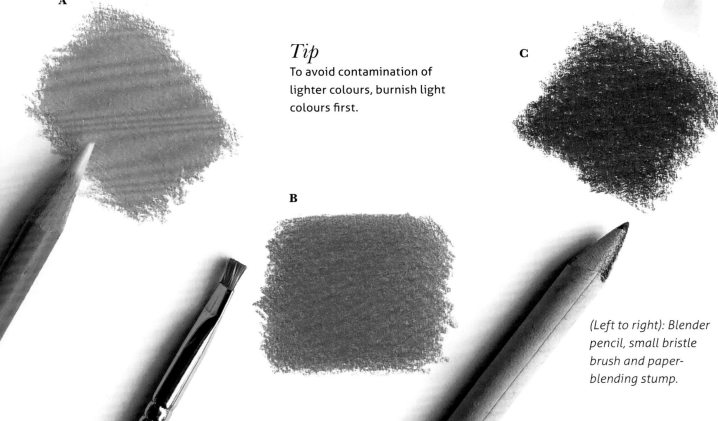

A

Tip
To avoid contamination of lighter colours, burnish light colours first.

B

C

(Left to right): Blender pencil, small bristle brush and paper-blending stump.

Here I have lightened the right side of the vase and also highlighted the area around the rim.

Erasing and lifting out colour

There are various erasing materials (see page 12) and different techniques for removing or lifting coloured pencil. With a kneaded eraser, you can lightly dab it on areas of colour to lift top layers and leave bottom layers intact (**F**). Note that when the colour particles adhere to the eraser, it will need to be re-kneaded in order to absorb the colour before moving to another area, otherwise they will transfer to the drawing surface.

With a battery-operated eraser, eraser pencil or mechanical pen-style eraser, you can lift fine lines and areas of colour. This is especially good for creating highlights and cleaning up edges.

Take care when erasing so as to avoid damaging the paper surface or texture. Test an eraser on a small area or scrap paper first to ensure it is the correct method for your drawing.

Sgraffito

The sgraffito technique involves scratching away the top layer of colour to expose a lower layer or the paper surface. You can use a small utility knife to do this (**G**). Keep the knife at an angle and scrape the surface lightly to avoid damaging the paper. An embossing tool will allow you to create an impressed line and leave areas of the paper visible. This technique is useful when creating animal whiskers, hairs or veins in a leaf. We'll learn more about this tool while working on the Portrait of a Pet project (page 82).

F

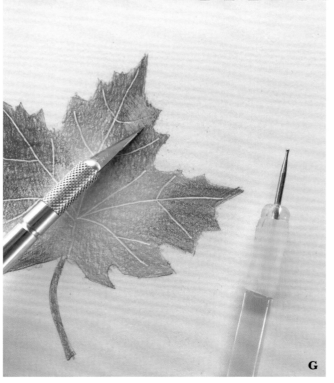

G

Here I am using a utility knife to scrape off top layers of coloured pencil. I also used the embossing tool to impress lines into the paper where the leaf veins will remain white.

Sketching and Composition

Sketching on paper is good practice when putting ideas and subjects together for a drawing, while composition involves arranging visual elements so that everything works together as a whole and keeps viewers engaged. Both these techniques will be invaluable when composing your work of art.

My new students often say on their first day of class, 'I can't even draw a straight line!' And my answer is, 'Neither can I!' The shapes we draw consist of a series of curved, angled or straight lines that we evaluate, erase, redraw and sketch some more. I always begin my drawing with a graphite pencil unless I'm working on a dark surface, in which case I use an erasable white pencil in order to see my pencil marks.

I use transfer paper to transfer my initial sketch onto good drawing paper. I'm using white transfer paper here so that I'll be able to see the lines on the dark red surface.

I often start on sketch paper by drawing lightly with graphite pencil to allow for alterations and erasing. I draw the shapes and outlines, then fill in the characteristics and details. As my composition is finalized and I am satisfied, I will transfer it to good drawing paper using tracing paper and/or graphite transfer paper (**A**).

The most important first step before even making a mark on the paper is to really study the object(s) or scene you want to draw. Decide what interests you most about the subject and how

Here the use of line depicts the white foam of the surf. The texture of the surf contrasts with that of the rocks surrounding it.

you would like to portray it. Observe the shapes, their proportions, how the shapes relate to one another, their details and textures (**B**). Also look at positive space and negative space (**C**). Simplify your beginning sketch by developing and placing large shapes and forms where you want them on the page, then add the details later.

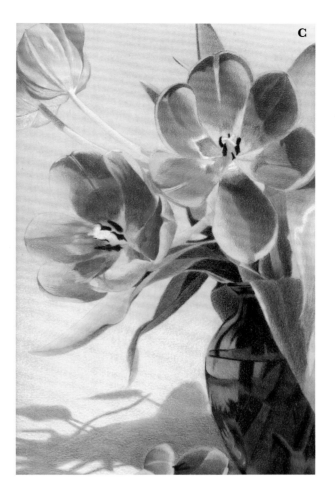

C

Small tonal value sketches can be very useful when beginning a drawing (**D**). I often create a quick sketch of my subject with graphite pencils, placing just three tonal values – light, medium and dark. This allows me to evaluate the design and make adjustments to light and dark areas, form and composition before adding colours.

This drawing of tulips contains some interesting negative spaces and illustrates different textures between the tulips and the vase.

Compositional sketch drawn while in New York City that shows tonal value, space, line, shape and textures.

Tip

I plan my drawing out in graphite pencil and then erase or lighten graphite lines, because once coloured pencil is added, you won't be able to erase the graphite.

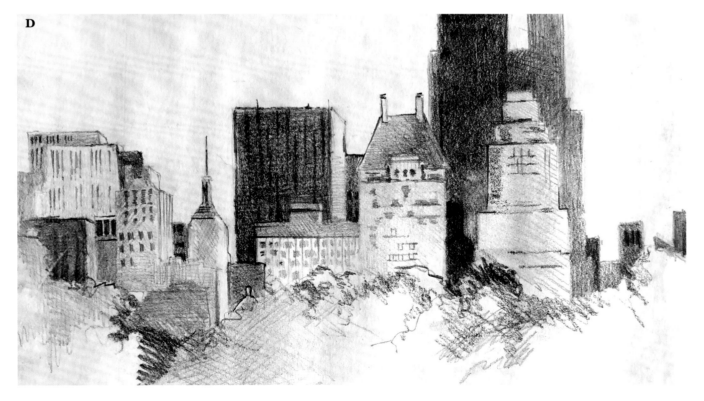

D

Elements of composition

If you want your picture to have a successful impact on viewers, you will need to create a strong composition. Several design elements are used to arrange the subject(s) in a pleasing way, and an artist will strive to make them all work harmoniously to give a sense of unity. The ability to see and understand these elements will help you produce a great drawing and composition, so let's look at each of them in turn.

In this drawing, the use of line creates a circular motion and leads the viewer's eye around the page.

SIZE

When beginning a drawing, the first choice is to decide on the size of the subject to determine its importance. Will it be life-sized, larger or smaller? Placement on the page is also important. If the subject is centred on the page, it will show stability and balance. Cropping the sides or moving the subject off-centre creates visual interest.

COLOUR

To create colour harmony in a drawing, see pages 14–15.

SPACE

Space is about the relationship between positive space and negative space. Positive space is the subject or subjects you are drawing. Negative space is the space within, between and around the subjects, and helps balance the composition: too much negative space can make a drawing feel empty, while too little may cause it to look crowded.

SHAPE

All subjects are made up of basic shapes or forms that relate to each other in the drawing. Variety in shapes will lead the viewer's eye around the drawing.

LINE

Line creates activity or motion in the composition and suggests the direction of movement. Lines that are angled or

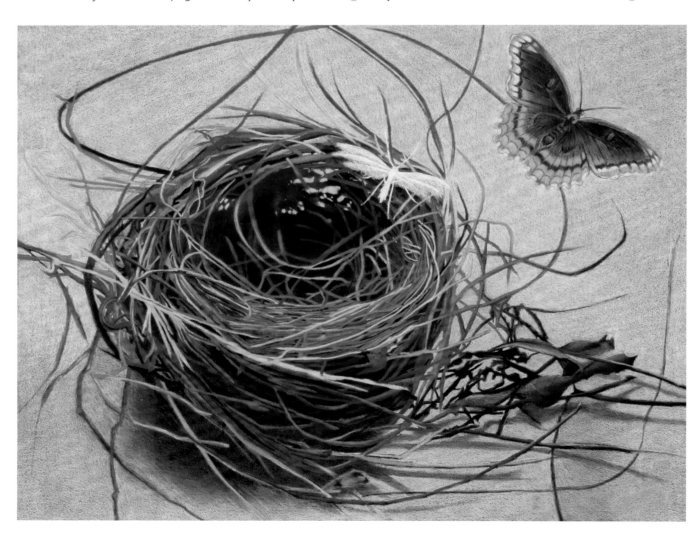

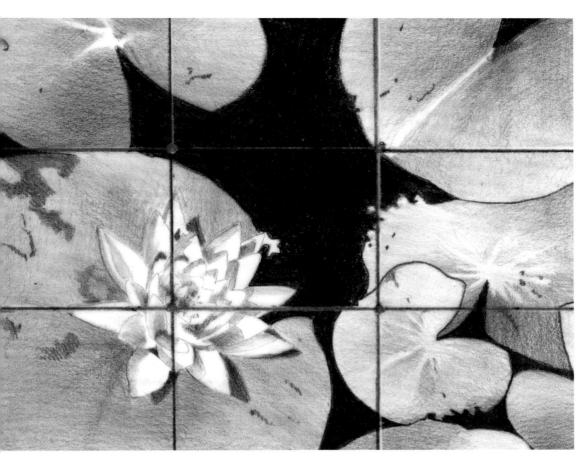

In the rule of thirds, the picture plane is divided into a grid. Important subjects are positioned on the lines or where they meet.

curved add visual interest and movement around the drawing. Horizontal lines imply tranquillity and rest, while vertical lines suggest power and strength. A contour line is the outline or silhouette of an object or figure. It helps build dimension and show changes within an object.

MOOD

Mood is when the artist elicits an emotional response from the viewer through elements such as lighting, colour or compositional design.

TEXTURE

Texture refers to the surface of objects – for example, they may be smooth, rough or shiny. We vary textures and patterns in subjects or elements to create visual interest.

TONAL VALUE

A drawing should have a full range of tonal values, from light to dark, in order to create good contrast. Light shapes will come forwards and dark shapes recede. A darker area next to a very light area will stand out and attract the viewer's eye. See page 16 for further information.

Together these design elements create the focal point of a composition – the main subject or centre of interest that pulls the viewer's eye into the drawing and leads it around. The focal point can be an important feature, an area of high contrast, or a form or shape that stands out from the others. Without a focal point, your drawing may have no real direction or purpose.

A popular way to help place focal points and compose an interesting composition is the rule of thirds. This involves dividing an image into nine equal parts using two horizontal lines and two vertical lines, as shown in the image (see above). Focal points are then placed along the lines or at the intersections. In landscape or seascape drawings, positioning the horizon line above or below the centre of the picture plane will make it more interesting.

Tip
A good composition keeps the viewer's eye moving around the drawing. Colour, light, line and shapes are all ways to achieve this.

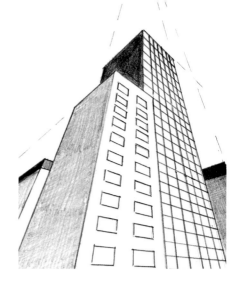

Perspective

Perspective is a technique used for creating the illusion of depth and distance. It gives a drawing form and conveys space. Perspective refers to the art of making two-dimensional objects appear three-dimensional. It is a fundamental concept that needs to be understood in order to create the illusion of space and realistic, believable scenes.

Artists use a variety of perspective techniques to create the illusion of depth and distance.

One-point perspective shows things converging towards a single vanishing point, becoming smaller as they recede into the distance. Two- and three-point perspectives are better for adding realism. Aerial or atmospheric perspective establishes a foreground, middle ground and background in a picture to create a sense of depth.

Basic or linear perspective is where parallel lines appear to meet as they get further towards the horizon, where they disappear. The point at which the lines meet is called the vanishing point.

One-point perspective

In one-point perspective (**A**), lines converge towards a single vanishing point on the horizon line. Objects appear smaller as they get further away, giving a sense of depth and distance. An example would be if you were to look directly down a long straight road. Practising one-point perspective is a good way to learn and become familiar with perspective.

One-point perspective shows how elements appear to get smaller as they move further away.

Two-point perspective

Two-point perspective (**B**) has two vanishing points, which are usually outside your actual drawing and far away from the scene. Two-point perspective is helpful for drawing geometric objects and buildings that are somewhat far away when looking at them straight on.

Three-point perspective

Three-point perspective (**C**) is used for a more extreme view from a very low or very high vantage point. It uses two vanishing points on the horizon line and a third point either above or below the horizon. Three-point perspective can create the illusion of height or depth in a subject.

A

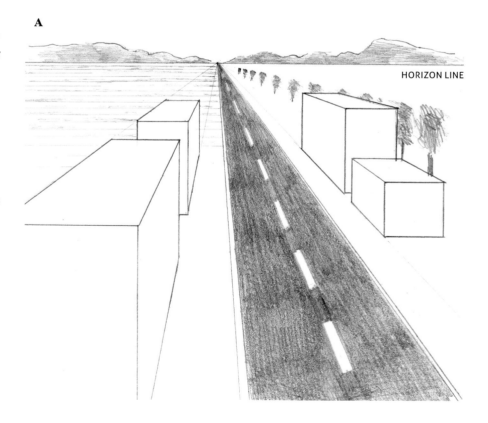

HORIZON LINE

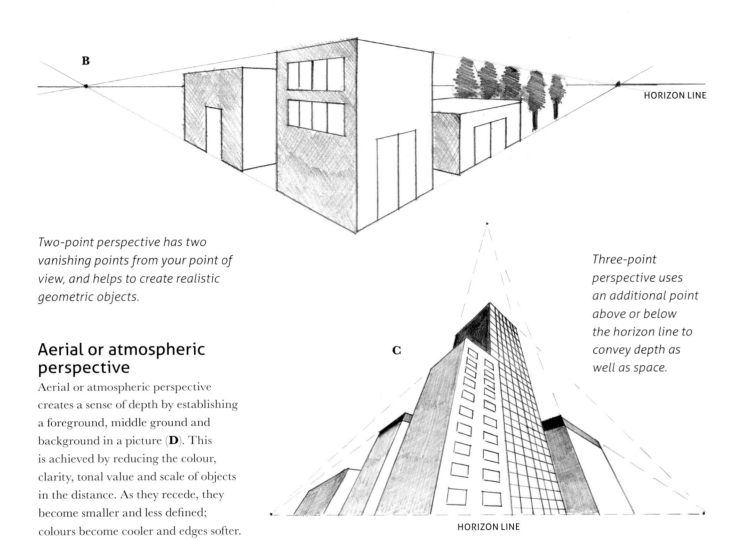

Two-point perspective has two vanishing points from your point of view, and helps to create realistic geometric objects.

Three-point perspective uses an additional point above or below the horizon line to convey depth as well as space.

Aerial or atmospheric perspective

Aerial or atmospheric perspective creates a sense of depth by establishing a foreground, middle ground and background in a picture (**D**). This is achieved by reducing the colour, clarity, tonal value and scale of objects in the distance. As they recede, they become smaller and less defined; colours become cooler and edges softer. Atmospheric perspective can add mood, beauty and drama to a scene such as a landscape, which you will learn more about in the project on page 42.

Now we have learned about colour theory and fundamental drawing techniques, it's time to put this knowledge into practice and start working on the projects.

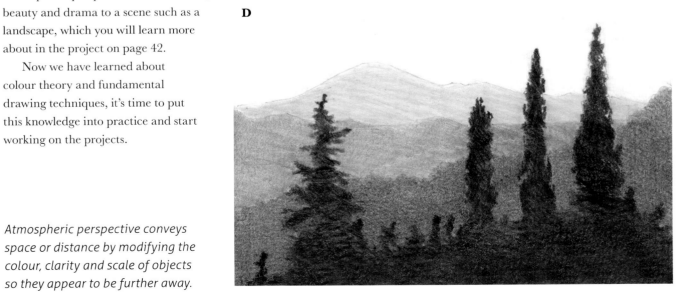

Atmospheric perspective conveys space or distance by modifying the colour, clarity and scale of objects so they appear to be further away.

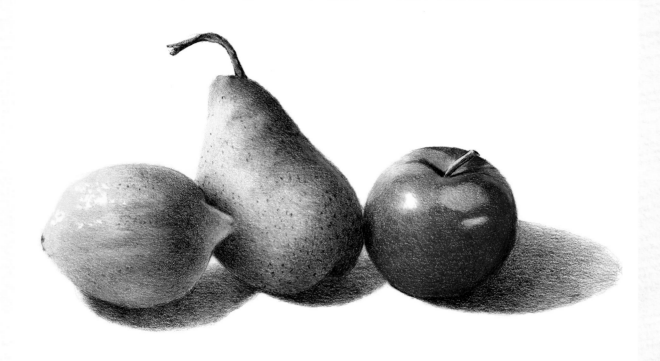

Fruit Still Life

This project will get you thinking about how best to arrange objects for a pleasing composition and will enable you to practise making realistic representations of simple three-dimensional shapes. It will also show you how to build up strength and harmony in colour tones as well as hint at highlights and reflections.

PENCILS USED: PRISMACOLOR

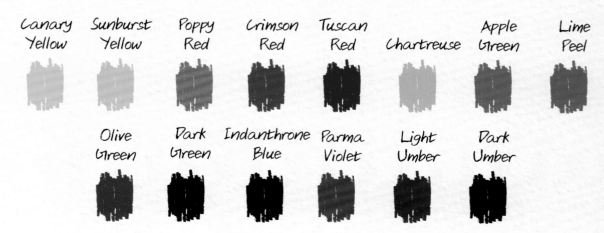

Canary Yellow · Sunburst Yellow · Poppy Red · Crimson Red · Tuscan Red · Chartreuse · Apple Green · Lime Peel

Olive Green · Dark Green · Indanthrone Blue · Parma Violet · Light Umber · Dark Umber

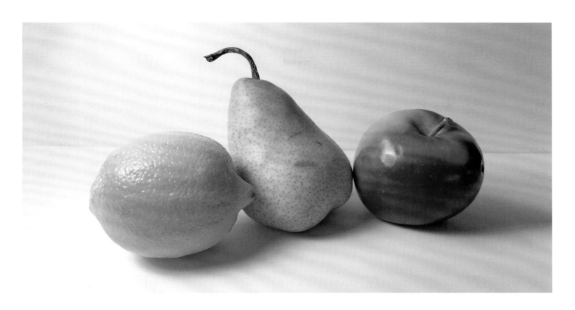

Bring objects close together to unify the composition, with edges touching or overlapping.

Working on a simple still life of a few objects is a good beginning for creating many other types of artwork. Still life drawing will assist you in becoming more familiar with how to lay out a group of various objects on paper, and improve your ability to sketch the different shapes and add tone and colour so the objects have dimension and characteristics.

CHOOSING MATERIALS

I chose a traditional white drawing paper for this project. It is 100 per cent cotton, which gives the paper a nice smooth texture to hold the colour. The paper is acid free and will retain its nice white colour for many years to come. I like to purchase a particular drawing paper by the sheet and then cut it to size.

I used Prismacolor pencils in this project because they work well with this particular type of paper. They are wax based and easily blended; I try to choose lightfast colours, but you can use similar colours in any brand you like.

PLANNING THE COMPOSITION

For this still life, I chose a grouping of three pieces of fruit. Odd numbers of subjects in a composition are more dynamic and create balance and visual harmony. This is because the eye and brain want to group objects in pairs, while an uneven number keeps the viewer's eye moving around the page.

I placed the fruit on a white surface with a white background to simplify the surroundings so that the fruit was the only point of focus. It also meant I could clearly see the colourful shadows they created. I positioned a light to shine on the left side of the still life so I could study the lights, darks and shadows cast, as well as the variety of colour, texture and pattern in the fruit.

ESTABLISHING TONAL VALUES

When you are grouping objects, it is good to be aware of the positive spaces they create, as well as the negative spaces within, between and around them. You might find it helpful to take a photo of the still life and convert it into a black-and-white image. This will make it easier to see the light, medium and dark tonal values without the colour interfering. A good range of tonal values will help to create dimension and depth in a drawing.

Tip
If using a photo for reference, convert it into black and white so you can see the range of tonal values in the composition.

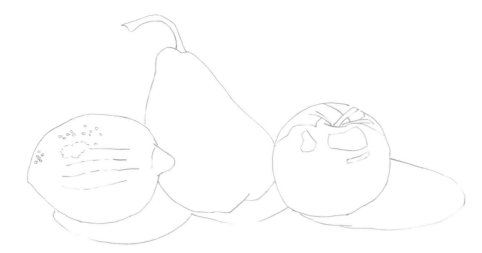

STAGE 1

Begin by drawing the shapes of the fruit and shadows, putting in details, markings, stems and white highlights for reference points. I have used darker graphite lines so they can be easily seen but I will lighten these with an eraser at a later stage.

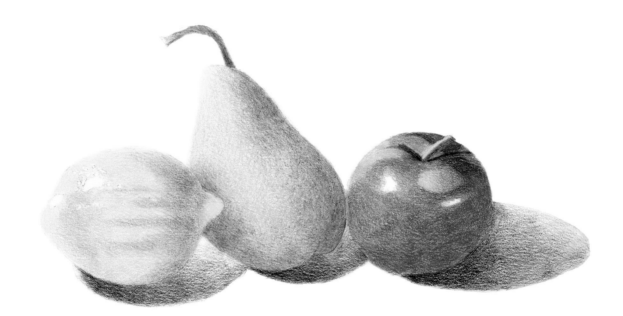

STAGE 2

Now you can block in base colours. Starting with the lemon, apply a light base of Canary Yellow, keeping your pencil strokes close together to create a smooth, even layer of colour. Add Chartreuse for the greenish tint that is on the left side and Apple Green on the right side of the lemon, near the point. Next, work on the pear, applying a light wash of colour using Chartreuse. Build tonal values with Apple Green and Lime Peel on the sides to show rounded form. Lightly colour the stem in Light Umber.

Moving on to the apple, apply Poppy Red, carefully working around the highlights you drew earlier. Add Crimson Red over Poppy Red on the right side of the apple and fade it out as it gets nearer to the light source. Apply Chartreuse and Apple Green to the areas near the top and base of the stem. Add Olive Green to the two areas where the stem is casting shadow on the apple. Lightly colour the stem in Lime Peel and Light Umber. Then create shadows with Indanthrone Blue, varying the lights and darks as shown.

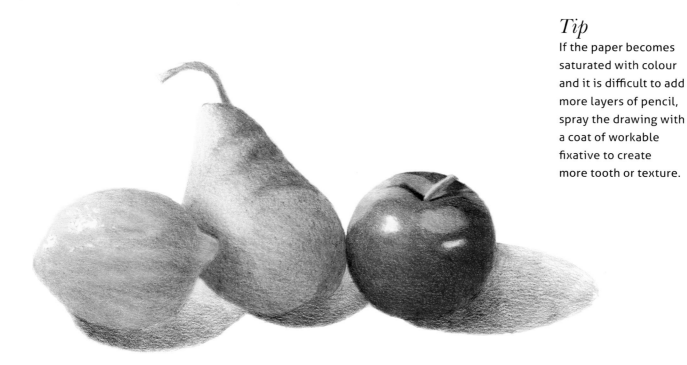

Tip
If the paper becomes saturated with colour and it is difficult to add more layers of pencil, spray the drawing with a coat of workable fixative to create more tooth or texture.

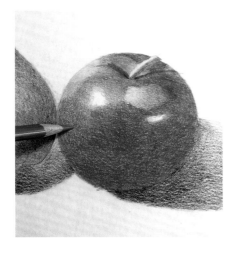

Coloured pencil is translucent, enabling layers to show through one another, so the green can be added over the red.

STAGE 3

This stage involves building up tonal values, form and colour, but do erase the graphite pencil lines before layering additional coloured pencil.

Lightly layer Poppy Red on the lemon, along the top, middle and bottom as shown above. Next, lightly add Light Umber to the pear, along the base, up towards the middle and to the right. Add Olive Green to show darker tones on the bottom and sides of the pear, where it touches the other fruit.

Working on the apple, add some Lime Peel on the left side, where there is a greenish tone under the red. I have lightly layered the red so I am able to add the green and let the two colours blend, creating the reflected light from the pear. Blend a layer of Olive Green onto the red, on the right side of the apple where the tonal value is darker. I often use the complement of a colour to darken or neutralize where the colour moves into shadow. And I like to emphasize an object by looking for other colours besides its natural colour to create visual interest.

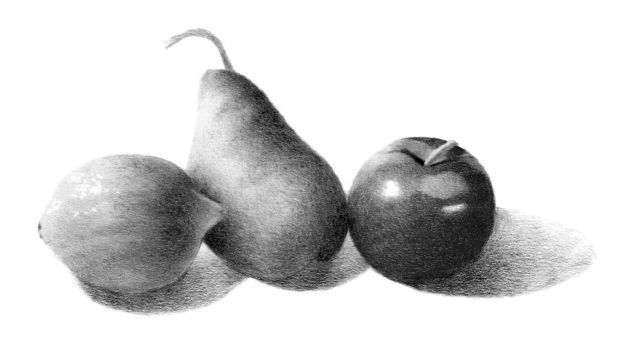

STAGE 4

Let's add more colour, deepen tonal values to create depth in darker sections, and find places where colour is reflected. The colours of objects grouped together will be reflected in one another. Here, yellow from the lemon is reflected in the pear, green from the pear is reflected in the lemon, and a little red from the apple is reflected in the lower right side of the pear.

Incorporate those subtle layers of colour, and continue to deepen the tonal values where the light turns to shadow. Add the complementary colour of yellow, which is Parma Violet, to the darker areas of the lemon to create rich, colourful darks. Apply Crimson Red to the pear and Tuscan Red to the darkest part of the apple to create a full range of tonal values in your still life. Now deepen the shadows at the base of the fruit to create the darker tones. Use more pencil pressure when adding layers of colour (see page 18) to deepen the colours.

I rarely use black pencil. Instead I prefer to create my dark tones by mixing Dark Green, Tuscan Red and Indanthrone Blue. Experiment with layering the three in different orders for variations of colourful darks.

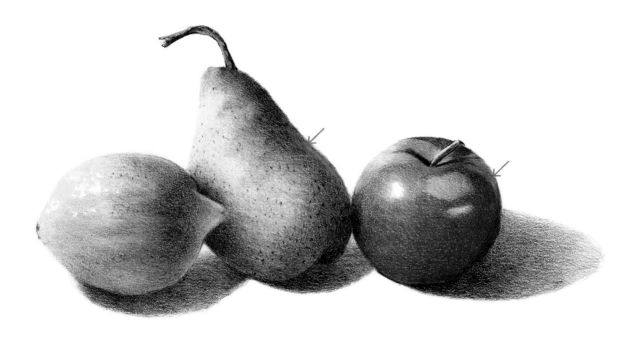

STAGE 5

Finally, it's time to define the details and create colourful shadows. Using the Dark Umber pencil, add detail and dimension to the pear and apple stems. The pear stem has more texture so add more lines and just give the apple stem a dark right edge.

Add some of the darker dimples to the lemon and add speckles to the pear, keeping them random and varying the distance between the speckles. Don't attempt to include every marking, because it will look unnatural: the viewer's eye will connect what isn't there.

The arrows indicate where light is bouncing back as reflected light on the right sides of both the apple and pear, making them appear shiny. You can show this by burnishing those areas using a white pencil with a hard pressure.

Now introduce colour to the shadows. Start by adding Parma Violet to the Indanthrone Blue base, then apply colours to show where the fruit is reflected in each shadow: Sunburst Yellow and Poppy Red from the lemon, Apple Green and Crimson Red from the pear, and Crimson Red and Tuscan Red from the apple.

I sometimes use a contour line in small areas to define a form or an edge. Contour lines can give visual interest to an object and move the viewer's eye around the forms. Don't outline the whole object, just parts, and let the line fade at the edges.

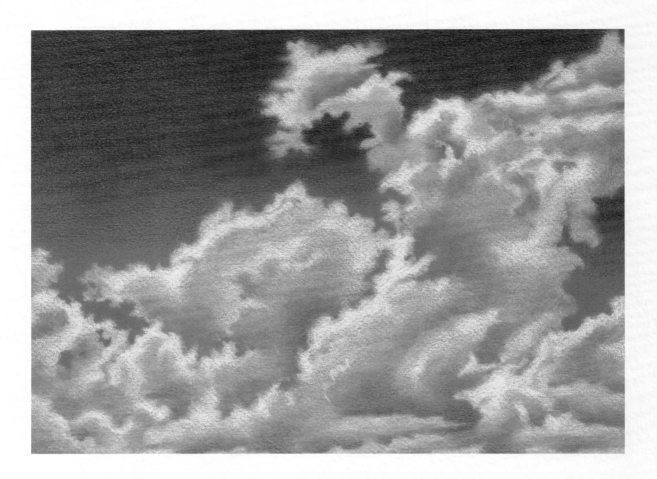

Clouds in a Blue Sky

In this scene, the cumulus clouds are our main subjects. We'll create an atmospheric sky by building colour and shadow in the clouds to give an illusion of depth and dimension while maintaining their soft, fluffy essence. This project will strengthen your ability to draw clouds, whether they are the focus of a picture or just a part of a scene.

PENCILS USED: CARAN D'ACHE LUMINANCE AND PRISMACOLOR

White	Light Cobalt Blue	Ultramarine Violet	Periwinkle Blue	Genuine Cobalt Blue	Cobalt Blue Hue

Clouds are something we're all used to seeing, but have you ever really given them much thought? When you're drawing a subject, it's important to think about what you're trying to portray.

Clouds come in many shapes and forms. Look into the sky and watch the clouds float by. You'll notice their different appearances and how they change in perspective – they are fluffier and fuller overhead, then become smaller and flatter as they recede to the horizon. Clouds near the horizon have flat bottoms, similar to a ceiling.

Clouds can be warm or cool in colour, depending on the atmosphere around them. They absorb different colours from adjacent clouds, the sky and the ground. They also change in colour and tonal value when viewed from the foreground to the horizon. The tops of clouds overhead will be lighter and brighter because they reflect the light of the sun. Towards the horizon, cloud colours are deeper and darker.

Clouds can add atmospheric movement to a sky in a drawing and make it more interesting. I'm sure you have seen sunsets where the clouds take on beautiful colours such as pink, orange and violet. Have you ever noticed that cloudy sunsets are much more beautiful than a sunset in a clear sky?

I selected this reference photo because I like the composition of the clouds and the sky working together as a whole. The ratio of clouds to sky is approximately two thirds to one third, and the clouds move in a diagonal form, leading the viewer's eye around the page.

CHOOSING MATERIALS

I decided to draw on a blue-grey toned paper because this background colour will complement and unify the scene. It is also one of the colours seen within the clouds themselves. The blue-grey surface is already a medium tonal value, so we won't have to work as hard to get to the darker tonal values in the sky and clouds as we would if using white paper.

I chose the colours for this from both Luminance and Prismacolor pencils; I was looking for particular colours, so I needed to choose from different brands. Both are a good choice for working on this paper.

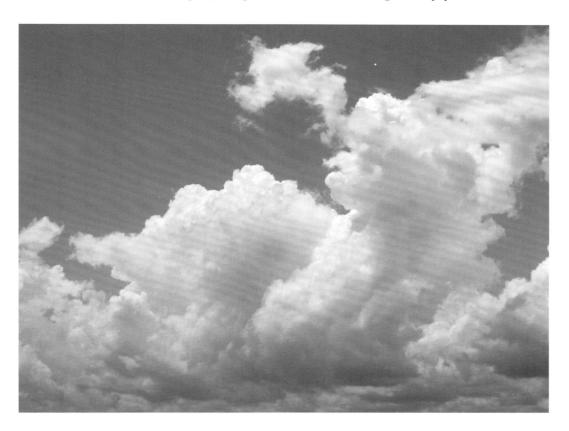

Tip
Coloured papers cut down on drawing time because there is already one colour and tonal value established. Here a blue-grey toned paper complements the cloud colours and speeds up the drawing process.

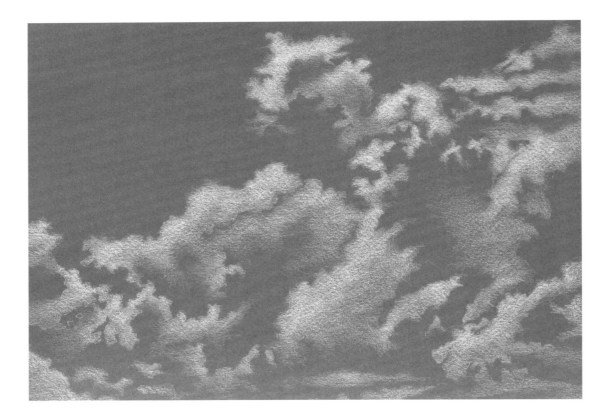

STAGE 1

The cloud formations in the reference photo are very detailed, so we will simplify some of the shapes. Don't attempt to replicate every single little element. Begin by drawing the outlines with an erasable white Col-Erase pencil so you won't have to worry about erasing graphite lines later on. The white pencil will show up nicely on the coloured surface and blend easily with the coloured pencils.

Note the shapes and sizes of the clouds, and how they become darker in tonal value and flatter as they recede to the bottom of the page. I have left out the horizon so we can focus on just the clouds, but you know the horizon is just beyond the bottom edge of the page. Be aware of the negative spaces of sky between some of the cloud forms and little 'sky holes' within the clouds.

Start with the White coloured pencil and begin drawing the wispy tops of the clouds with a light pressure. Maximize the light, airy feeling of vaporous clouds by applying the pencil with a very light pressure along the edges, keeping edges soft. Next, use a medium pressure to build layers of White pencil in the lightest and brightest areas of the clouds.

I often test out colours on a scrap of the coloured paper I will be working on, as they can look very different on a tinted background. Lead pencil won't show on coloured paper, so I used an erasable white drawing pencil to sketch the drawing.

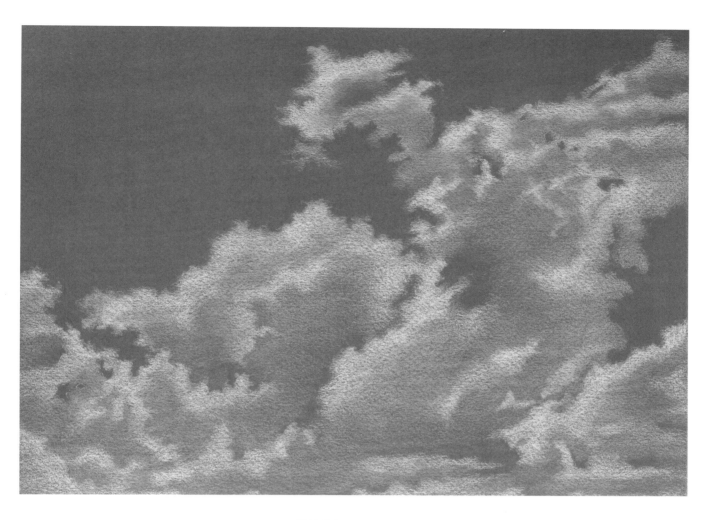

STAGE 2

Tip
Some pencils are better for blending than others: the pencil's waxiness and the amount of pigment in it will affect how malleable it is.

Using Light Cobalt Blue, begin to lightly and carefully blend blue alongside the white in order to make a soft transition. Clouds are soft and vaporous, so colours should be gently transitioned into each other as each new colour is added without leaving hard lines.

Take the Ultramarine Violet pencil and add areas of violet to parts of the blue where the clouds turn away from the light and become darker in tonal value. The violet hues add variety and interest, and start to suggest depth in the clouds as they retreat from the light. The paper is textured and some of the background will show through and mix with the colours that are applied. At this point, we have a lovely analogous colour drawing and could almost stop right here and call it finished.

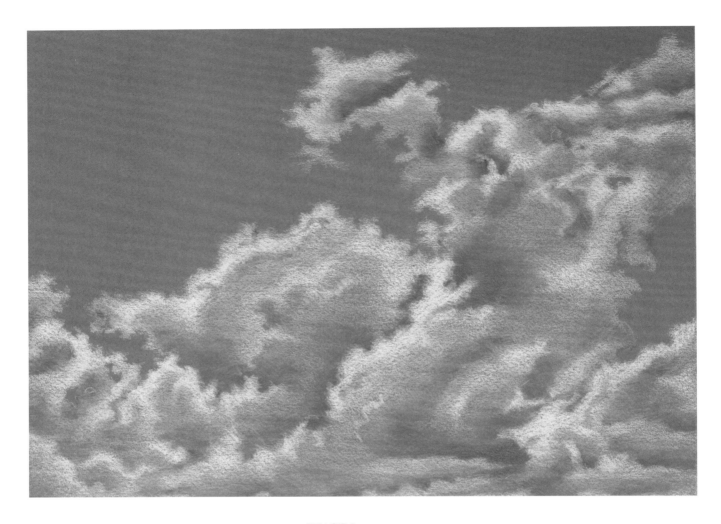

STAGE 3

The next colour we will add to deepen tonal value is Periwinkle Blue. We need to create depth and shadow within the cloud forms, and we want to build areas that are darkest and where the clouds swirl and curve around each other. The darker tonal values against the white will make them pop and accentuate their wispiness and form.

All the colours and tonal values have been applied to the clouds, but we may want to adjust one or more of the colours in certain areas. Perhaps there are places where colours could be built or dark areas that could be lighter? We've applied the layers lightly, so the paper's texture will still accept more layers and we can go back into areas and deepen colour, or even add lighter colours on top of darker colours. I often see that I need to build whites or add more wispy white areas to the tops of the clouds.

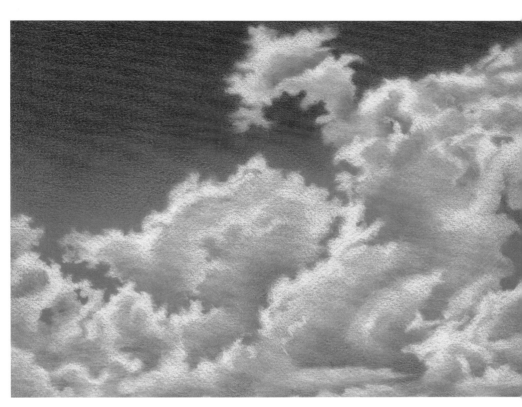

Burnish the sky colour with a round bristle brush to diminish texture and fuse colour into the paper.

STAGE 4

Now it's time to create the areas of clear blue sky. Skies are lighter and warmer near the horizon, and cooler and darker as they ascend. I have chosen two colours: Genuine Cobalt Blue for the lighter sky area and Cobalt Blue Hue for the sky towards the top of the drawing.

Start by lightly laying in each colour separately and working them together towards the centre. Work in small areas, using short strokes and cross-hatching to blend and smooth out strokes. As you get to areas where the two colours meet, try to fuse them together, working the darker colour over and into the lighter colour.

The sky is a smooth surface, so we want to create an evenly blended layer of colour. Once you're satisfied with the colours of the sky, burnish them by using a small round bristle brush to mush them into the paper so that less of the texture shows. Work in small areas and use a circular motion with the brush. Turn the paper around and burnish in different directions.

The last step is to evaluate the drawing. Perhaps some of the white cloud edges need to be adjusted or blended into the sky? You may even want to burnish some of the cloud colours, but be sure to use a clean bristle brush or else colour will transfer onto the page.

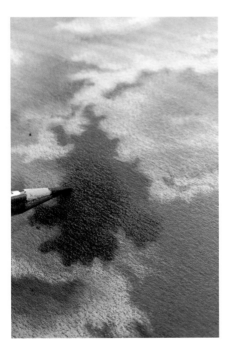

Lightly blend the two sky colours together. I find it easiest to layer very lightly where they meet and blend the darker blue softly into the lighter blue.

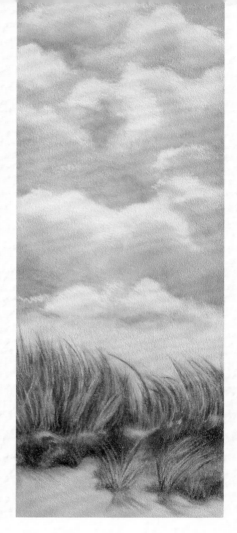

Both sky and clouds have some of the softest edges you can find in nature. A balance between soft and hard edges is very important within the drawing, as edges will help you describe the volume and softness of the clouds as well as their translucency. The grasses have wispy edges and a different texture from the clouds. The movement of the grasses and wispiness of the clouds helps illustrate this breezy day.

I worked on dark blue paper to create this wintry night sky. The moonlit sky is cloudless and soft, and I blended the colours from the lightest, closest to the moon, to the darkest edges.

FOCUS ON
Dynamic Skies

A sky can be the main focus of a drawing or set the mood for a cityscape, landscape or seascape. In this study we will learn about atmosphere, colour, light and shape in skies, and how to make them dramatic or quiet.

Skies are constantly changing colour due to the way light travels through the atmosphere. Molecules and dust particles in the atmosphere change the direction of light rays and create various colours within the sky. At sunrise and sunset, when the sun is lowest on the horizon, light passes through more of these atmospheric particles, creating more colour than during midday. If we look directly up at the sky above us, we notice clouds are lighter and the sky is brighter because there are less atmospheric particles obstructing our view.

Clouds are forever moving and changing too. You'll notice they become smaller in the distance, just like any other object in terms of linear perspective. They also take on a slightly different colour as they get closer to the horizon. As white clouds recede they become greyer in colour and lighter in tonal value. See pages 26–7 for more information about perspective.

A spectrum of colour

On a clear day, the sky appears blue; but if we really study it, we can see many other hues such as green, pink and yellow. On a rainy day the sky isn't just grey; it contains other hues such as blue, green and violet. Filtered light creates changes in sky and clouds, and you will add a variety of colours into your scene.

I avoid using only pure hues, as this can make clouds and sky look unnatural. Instead I add grey tones to neutralize the brighter colours and balance the scene. There are often grey areas in the sky and in the shadows of clouds that can be created by layering coloured pencils (see page 18). If I am working on a landscape, I might add colours from the land below to harmonize the scene. If I am working on a seascape, I would add colours from the sea and a few from the sandy shoreline to complement the scene.

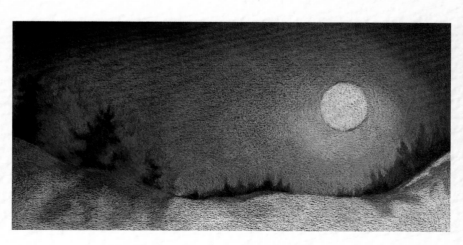

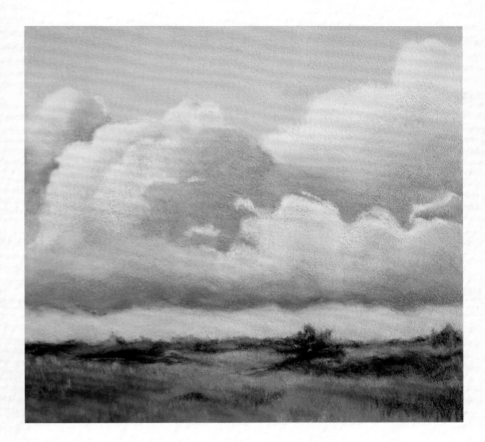

In this drawing I overemphasized the colours and tones in the clouds, adding bright blues, pinks, violets and even hints of green. Sunlight is reflected in the tops of the clouds, and lower clouds become a little greyer as they near the horizon. Oranges and yellows in the sunlit clouds and in the landscape below help unify the scene. You will also notice the variety of hard and soft edges within the cloud forms.

Hard and soft edges

Clouds generally have very soft edges that fade or transition into their surroundings, though some clouds have hard edges in areas such as the top. A hard edge defines exactly where an object ends and the next object starts. Soft or hard edges will help you portray the volume of clouds, whether they are thick and opaque or translucent where more light passes through, showing soft colours. Finding a balance between hard and soft edges in nature is important.

On a clear day we see pure white in the tops of clouds, where sunlight is reflected. The colour of the light and the reflection of the sky will affect the white colour in the clouds. To give the clouds a soft glow, you can add tints of different colours to white. I used White coloured pencil in the Clouds in a Blue Sky project (see pages 34–9) because the blue-grey paper showed through the white pencil and softened the brightness.

Use your own artistic licence and leave out elements that you don't want in the drawing or that aren't helping your composition. Have fun experimenting with colour for clouds and sky, and altering cloud shapes to your liking.

I chose analogous colours for the sky and complementary colours for the land to create this vivid scene from my imagination. Orange paper gives the scene a base of orange and an overall warm glow.

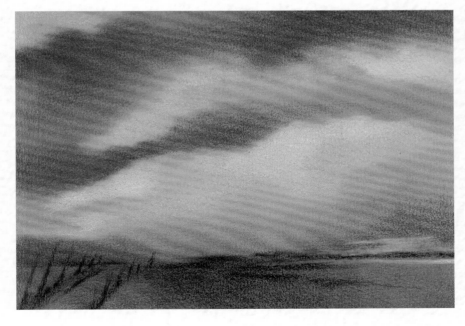

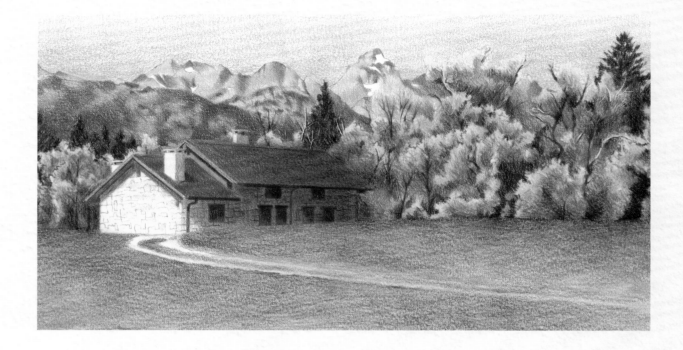

Layering a Landscape

*In this project we will create a landscape with a foreground, middle ground
and background to practise perspective. We'll also work with colour, line, shape
and texture, and explore ways of adding visual interest to the scene.*

PENCILS USED: CARAN D'ACHE PABLO AND LUMINANCE, AND PRISMACOLOR

Canary Yellow Golden Yellow Fast Orange Ochre Chestnut Umber Beige Grey

Dark Grey Indian Red Mahogany Tuscan Red Putty Beige Greyed Lavender Manganese Violet Periwinkle Blue

Royal Blue Dark Sap Green Moss Green Light Olive Olive Black Malachite Green Bluish Grey

When creating a landscape drawing, you need to decide what you'd like to portray about a particular place and how you can best capture the essence of your surroundings. Colours, atmosphere, detail and tonal values will all work together to create an alluring landscape.

Working *en plein air* – a French phrase meaning 'in the open air' – will give you a good sense of moments in time, allowing you to soak up light and ambience. When choosing an area to sketch for a landscape, study colour, shape and texture in nature, and think about what intrigues you the most. Remember that there is no perfect composition, and you may change or remove unwanted objects you don't want in the scene.

Drawing en plein air has to be done quickly, as the light and atmosphere swiftly change throughout the day, and it can be challenging. I like to write notes and make colour jottings in a sketchbook along with my drawing. I also take several photos so I can recreate the scene when working in my studio.

USING PHOTOGRAPHIC REFERENCE

Drawing from a reference photo can make life easier than working outside, as you can work on your creation over a longer period of time. But bear in mind

Sketching outdoors can help you get a sense of the scene.

that this will limit your vision to a flat, rectangular scene, so you must add your own insights into the drawing. Photos can also darken areas such as shadows.

For this project I chose a reference photo of a landscape with woodland, a house in the foreground and mountains in the distance. I like the road leading to the house, as it breaks up the foreground. I also like the warm red roof, yellow in the trees and purples in the mountains, so I emphasized these with colour. There's a great variety of textures, too. The foliage and grass are rough, the mountains are rocky and uneven, and the sky and roofs are smooth, with an illusion of smooth stone on the sides of the house.

PLANNING THE COMPOSITION

As I planned a composition for the drawing, I asked myself what I wanted viewers to see. To add visual interest, I made the horizon line high, so there would be less sky and more foreground, making the scene more interesting than if the horizon line had been placed directly in the centre. I also made the building slightly smaller, so it didn't appear so dominant, and moved it slightly to the left so it wasn't quite so centred.

CHOOSING MATERIALS

I chose to draw this scene on off-white paper and decided it would be mainly warm with a small percentage of cool in the mountains and sky – a suggested ratio of warm to cool in a composition is 70 per cent to 30 per cent.

I chose Caran d'Ache Pablo coloured pencils for this project as they are an oil-based pencil with a harder tip that works nicely for creating thin lines such as for the trees and foliage and have sharper edges for working on areas such as the house and roof lines. I added a few Prismacolor and Luminance pencils for colour choices that were not available in the Pablo range, but you can chose the ones you like – there are many brands of good pencils on the market.

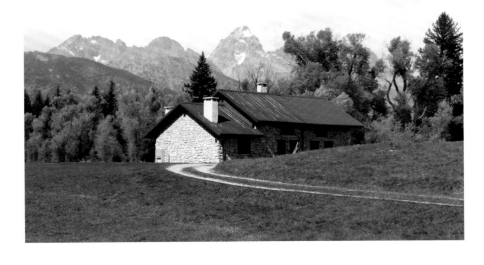

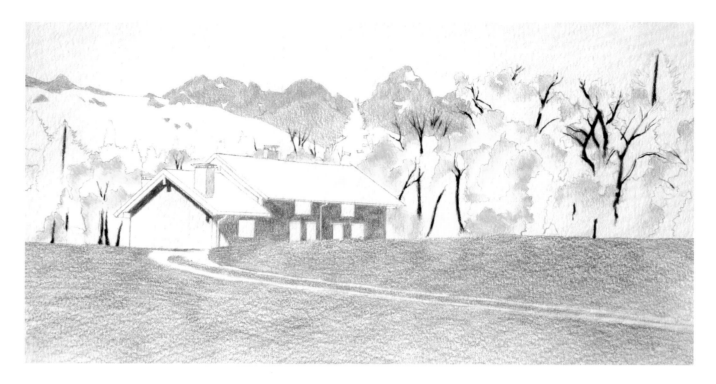

STAGE 1

There are many elements in this scene, especially with all the different trees and various mountains. So the first job is to simplify all these elements by selecting the main shapes and then sketching a quick outline of them.

Now you can start adding colour. Use an embossing tool to indent lines on the lightest parts of the branches so they will stay white. Then apply Umber and Chestnut to the tree trunks and branches, lightening your pressure at the ends of the branches so they blend softly into the scene.

Put Canary Yellow and Golden Yellow in the tops of the trees, where they will be the lightest colours. Roughly colour the grass with Golden Yellow, Ochre and Moss Green, then use Greyed Lavender and Putty Beige for the far mountains.

To draw the house, I suggest using a ruler for the straight lines and roof angles, and you may find it helpful to refer to the section on Perspective (see pages 26–7). Create shadows using Beige, Grey and Dark Grey. The chimneys are the lightest, so use Beige on these. Apply Grey to the side of the house facing away from the sun and use Dark Grey for the shadowed area under the roofline.

Tip
A landscape drawing is a placement of shapes. Start by finding the main shapes in your composition. Draw one main shape, then move on to the others. Block in the colour and tonal value of each shape, and add details later.

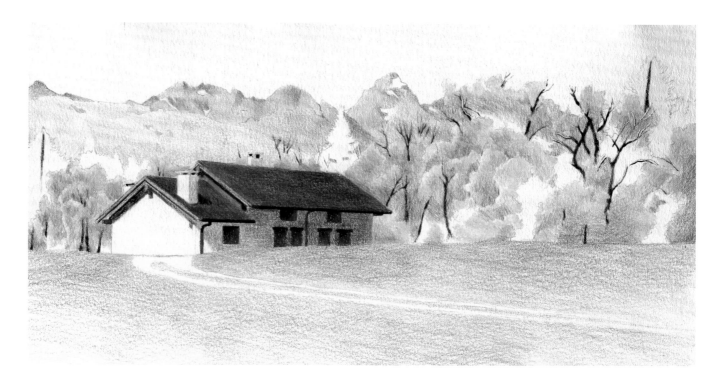

STAGE 2

As we have learned, atmospheric perspective is the way in which colour, tonal value and detail diminish as objects move into the distance, creating a feeling of depth. In this scene, objects in the foreground have stronger colour and contrast; warm colours come forwards, while cool colours fall back. As objects recede, colours lose their brilliance, so in the reference photo you'll notice that foliage on the faraway mountain is blue rather than green.

At this stage we are still blocking in shapes and adding base colours, as we don't want to get caught up in too much detail early on.

Add Light Olive and Moss Green to the yellow colours on the trees. You can use Canary Yellow and Golden Yellow to blend the green into the yellow tones. It's also fine to colour over tree trunks with lighter colours – the dark browns will still show or can be reapplied later. Add Putty Beige to the nearest mountain and Manganese Violet to the darker areas of further mountains that fall into crevices or shadow.

Now work on the house. I've eliminated the lines of different-coloured tones in the roof and made them smooth. Colour the roof with a light even tone of Mahogany and add Umber to the right side, which is darker in tonal value. Blend Indian Red on the lighter area to the left and on the small roof. Mix Golden Yellow and Indian Red for the small, orange-toned part between the two roofs. Colour the windows with Mahogany and add Tuscan Red to the tops and right sides, where the windows move into shadow. Colour the dark rooflines in Tuscan Red, then use a very light pressure to apply Mahogany to the roof edges facing the light. Add a layer of Bluish Grey to the side of the house.

Apply Light Olive to the grass and more Ochre to build colour and texture.

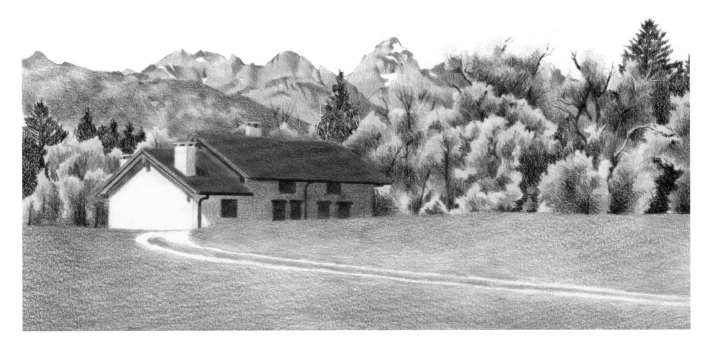

STAGE 3

Next, we'll start adding details and creating soft edges and hard edges.
We will also use other compositional elements of design to bring this scene
to life. We have already begun to use texture, and now we'll build shape and
line in the different elements in the scene. Look at the relationships of space,
particularly between the foreground house and foliage, then compare them
with the mountains in the background.

Put Olive Black on the foliage followed by Dark Sap Green. Also colour the
background evergreen trees with Dark Sap Green. Leave some areas of white
paper between branches to show where they part. Continue adding Dark Sap
Green to the darkest areas of the foliage to add depth.

Add Periwinkle Blue to the distant mountains to further define the crevices, then
add Royal Blue to the nearest mountain to define the dark foliage areas. Note that
although these colours are called blue, they actually appear to be more violet.

Add a layer of Olive Black to the side of the house to neutralize the blue-
grey and blend it into the foliage and shadow. As you build colours on all the
elements, you'll need to adjust the grass, so layer more of the same grass colours
with a slightly heavier pressure.

*Colours in foliage are roughly layered
next to or over parts of each other to
show the texture of leaves.*

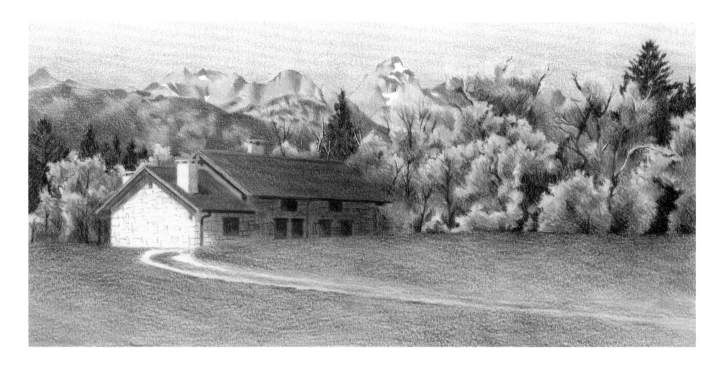

STAGE 4

Finally, we'll add more colour, but more importantly we need to unify the different elements so they form a whole. We'll do this by working on colours, tonal values, textures and by adding details. You may also make any additional changes you think necessary.

The only element we haven't yet coloured is the sky, so apply a layer of Greyed Lavender with a light, even pressure, and add Grey where the sky meets the mountains and foliage.

Using a stiff bristle brush, lightly burnish the grass and foliage – particularly the evergreen trees – to remove any paper showing through. Lightly add Fast Orange and Indian Red to the grass as well as some of the yellow areas in the foliage. I have also coloured over parts of the road so it blends in as it moves off the page, rather than leading the viewer's eye out of the scene.

Add Malachite Green to the dark areas of the nearest mountain just behind the house, then add Periwinkle Blue to the lighter areas to adjust tonal values. Add a layer of Bluish Grey to the mountains showing between the trees on the right.

Apply a light layer of Tuscan Red to the front of the house to darken the tonal value and blend it into the shadows. Then apply a light layer of Dark Sap Green to adjust the tonal value of the roof, darkening and blending it into the foliage. Dark Sap Green is the complement of Tuscan Red and will neutralize it into shadow.

Finally, using a sharp point on your pencil, add lines to pick out the stone texture on the house: on the side facing the sun, I used Grey with Putty Beige, and on the shadowed side I used Umber.

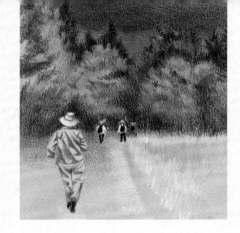

FOCUS ON
Figures in a Scene

Placing figures in a scene and sketching people or groups of people can help add a sense of movement and scale to your picture. You don't need figure-drawing or portrait skills in order to effectively place a few simple figures in your work.

Have you wanted to introduce figures to your drawing but were unsure how to do it? Figures can add interest and a touch of humanity to a scene as well as help tell a story or describe the setting. They can bring a picture to life by adding movement and balance for the composition. They can also help show scale and proportion. Figures are identified by their shapes. You should observe the gesture – motion or pose – of each figure and keep details to a minimum. Show perspective by decreasing the size of the figures to create a sense of depth and scale as they move into the distance (**A**). As figures recede, they become smaller and shorter. Just like any object in perspective, figures nearer to the viewer will show more detail and as they recede into the distance they become much less detailed (**B**).

You don't need figure-drawing or portrait skills to be able to add people to a scene: shape and gesture are the important parts, not all the details. Figures can be kept simple to support the drawing without becoming the centre of interest. Think of them as you would a subject – a group of shapes, colours, textures, light and shadow (**C**). You only need to add relatively little detail to facial features, fingers or feet.

Look for largest elements first and keep your drawing basic (**D**). Observe where light falls and where the form turns into shadow. Build up dark or shadow tones by working across the solid form. Include lines, when needed, for extra definition. Folds in clothing can describe movement and the contours of the body (**E**).

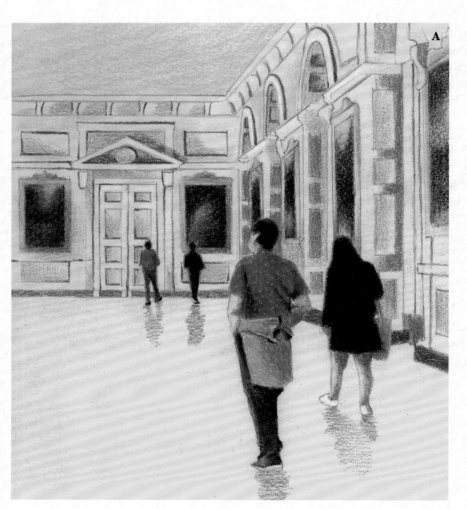

Figures should complement a scene, not dominate it. They can serve as a way to lead the viewer's eye around the picture, so when beginning your drawing, decide figure placement early on. Notice how the position of the feet and tilt of the bodies makes it more interesting than if they were all standing stationary.

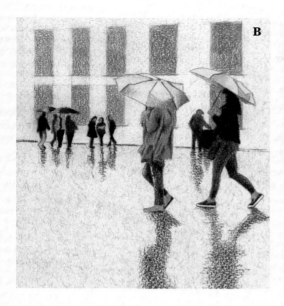

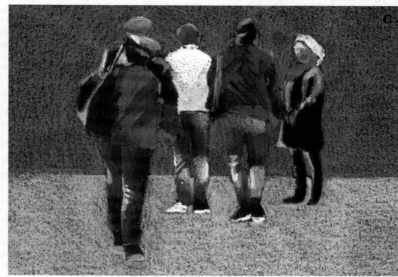

Grouping is important. Here I have superimposed the two foreground figures on the distant figure in between. The small groupings of figures in the background support the larger foreground figures. The shadows on the street help connect all the figures to the surface and create interesting foreground shapes.

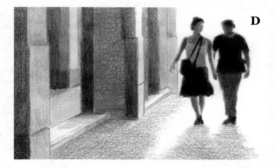

These figures are backlit as they walk into a corridor with light coming in from behind. I have omitted the facial features and kept shapes very simple and flat.

I used black paper to draw this colourful group of figures and integrated the paper into my drawing. Notice the negative spaces created within the group and how they overlap to make the group more interesting. The trousers and jackets consist of shapes of colour and light that show both form and movement.

Balance and shape

Balance in a figure is achieved by comparing the upper body with the hips. Begin by checking if the figure is standing upright or if their weight is shifted to one side or the other. Look for patterns of movement – how the body turns or changes in weight distribution and gestures.

To add further interest to the picture, vary the shape and pose of the figures rather than giving them all the same regimented stance. Shape and gesture should be enough to describe the figures accurately, showing characteristics such as tilt of the hips and angle of the shoulders.

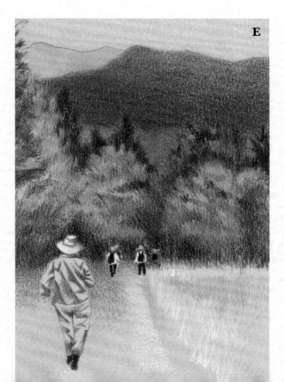

This ordinary landscape becomes more interesting with the introduction of figures. They show a sense of movement and perspective. We can also see that we are looking down a hill.

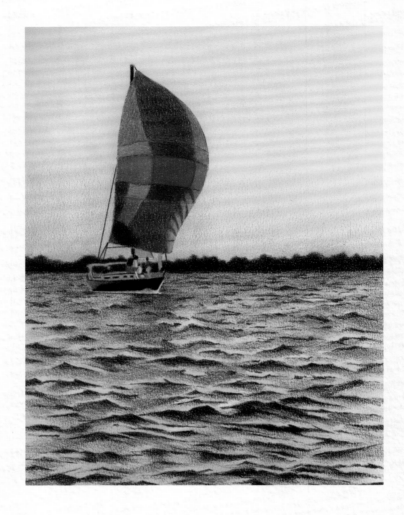

Seascape with Sailing Boat

In this project we look at ways to create the illusion of moving water. We'll also focus on how to capture reflections in water, portray a twilight sky and simplify a brightly coloured sailing boat.

PENCILS USED: PRISMACOLOR AND CARAN D'ACHE PABLO

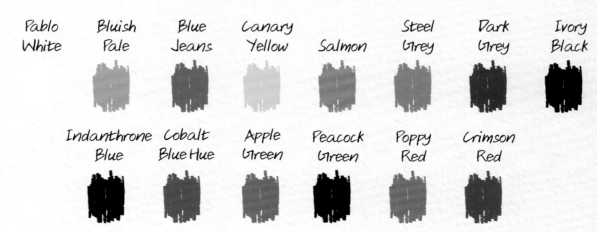

Pablo White	Bluish Pale	Blue Jeans	Canary Yellow	Salmon	Steel Grey	Dark Grey	Ivory Black

Indanthrone Blue	Cobalt Blue Hue	Apple Green	Peacock Green	Poppy Red	Crimson Red

It's always helpful to spend time observing your subjects and understanding their characteristics before beginning a drawing. I live in an area that is near the sea and a big sailing community, so I have had many opportunities to study and become familiar with water and sailing boats.

It may seem obvious to say, but water is fluid, reflective and transparent. Therefore the colours of water will vary, depending on the weather, light and its surroundings. In this picture the water is reflecting the twilight sky and the boat's colourful sail.

CREATING THE ILLUSION OF MOVING WATER
We're going to draw from a reference photo that has captured gently flowing water, and our aim is to create the illusion of moving water. Picture yourself at the scene. Watch the surface of the water respond to air currents and tidal movement, causing ripples and waves. The wind is behind the boat, pushing the craft and the waves towards you. Notice the waves are much smaller, lighter and closer together towards the horizon, but larger, darker and more scattered as they come closer to the foreground.

As the water rises up and forms a small wave, the side that faces the sunset is lighter, and as it turns away from the light, the other side becomes darker. Water between the waves is smoother and paler in tonal value and colour, especially as it nears the foreground.

Tip
Water is transparent, but it takes on colours surrounding it. Variations in colour and reflections are influenced by elements such as sunlight, sky, rocks and trees.

Still water will reflect a mirror image of an object above it, but in moving water the reflections are blurry. This sailing boat is mostly in shadow, so its reflection will be darker too. Much of the boat's detail can be simplified so the focus of the picture remains on its vibrant sail and the moving water.

CHOOSING THE RIGHT MATERIALS
The warm beige-toned paper I have chosen to work on is one of the twilight colours in the sky that is also reflected in the water. Using this tinted base made it easier to lay down colours and create a unified drawing. The waves and water consist of four colours: three blues (dark, medium and light tonal values) and a lighter tonal value, which is the paper showing through.

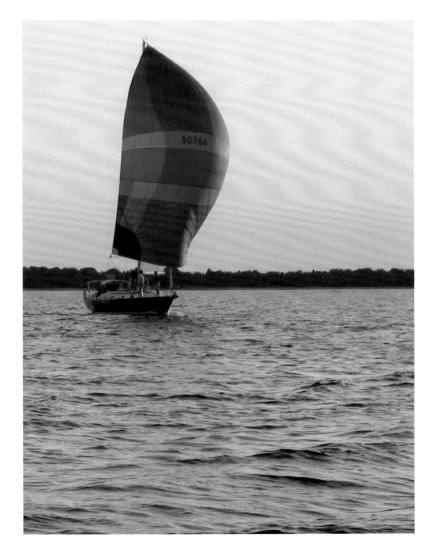

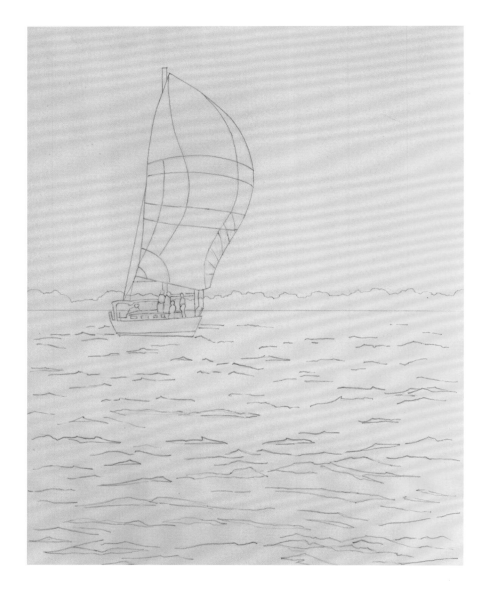

STAGE 1

The first thing we're going to do is to make a line drawing in graphite pencil.
Check that your horizon line is exactly horizontal and not centred on the page,
as the composition will be more interesting if the horizon is above or below the
centre of the picture. I have chosen to raise the horizon line above the centre
in order to put more focus on the water and waves. If I had put the horizon line
below this point, more of the sky would be showing, so the focus would be on
the sky instead of the water.

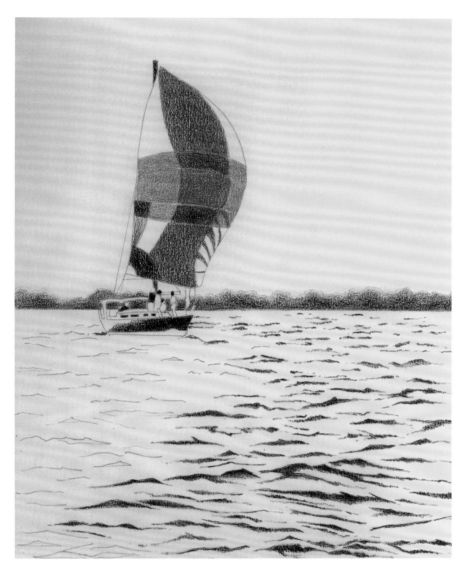

STAGE 2

Draw some horizontal marks for suggestions of wave patterns and begin to apply Indanthrone Blue on the crests of the waves where they turn away from the light. As we've already noted, the waves are more detailed in the foreground and become smaller and out of focus towards the horizon. Vary your pencil marks, angles and widths to reduce the waves into simple shapes and to add interest and show movement.

I have left some of the waves on the left side in graphite pencil to show my pencil marks before colour is applied. With light pressure, apply Indanthrone Blue to the row of trees in the background.

You can now draw the basic shapes and details of the boat and add suggestions of figures (see page 48). Apply Ivory Black to the top and front hull, the mast and parts of the figures as shown.

Next, colour the boat windows and the semicircular shape on the sail with Indanthrone Blue. Use Cobalt Blue Hue for the large central areas of the sail, including where they intersect the green stripes, and for the wrinkles at the sail base. Apply Indanthrone Blue to the left side of the sail. For the red stripe, use Poppy Red for the lighter part and Crimson Red for the darker part. Use Apple Green for the green stripes over the blue, intersecting with the green.

Tip

Waves are three-dimensional, with areas of light and dark tonal values. As the water rises up to form a wave, the crest turns away from the light and becomes darker. The back of the wave and surrounding water are facing the light so they will be much lighter in tone and will reflect the colours of the sky.

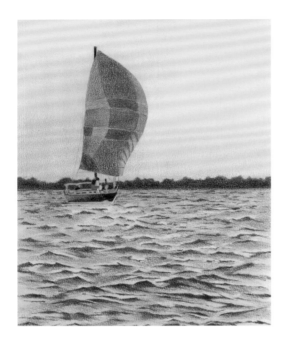

STAGE 3 (ABOVE)

Having applied Indanthrone Blue to the waves, we now need to apply a second colour – Blue Jeans. This is going to be the medium tonal value of the water. Apply Blue Jeans beneath the dark crests of the waves, leaving spaces above the crests and between the waves where the lightest blue will be applied later.

Apply Peacock Green over the Indanthrone Blue of the trees to make them blue-green, as you want them to recede into the distance and the twilight. A warmer green would cause the trees to pop forwards.

Next, apply Salmon on the left and right sides of the sail – the areas without colour from Stage 1. Lightly apply a layer of Cobalt Blue Hue over the Salmon except for the bottom-right area, as shown. We put these two colours together to show the sunset glowing through the sail.

STAGE 4 (BELOW)

I have chosen Bluish Pale as the lightest of the three colours for the water. Add Bluish Pale below and around the wave crests where the water is smoother and reflecting the light. Leave some areas of the paper surface showing as the reflected light from the sky.

Now it's time to work on the sky. Using a light pressure, apply Salmon at the horizon, moving upwards almost to the centre of the sky area. Allow the Salmon to fade as it nears the centre. Also using light pressure, apply Canary Yellow, beginning at the top of the page and moving downwards towards the Salmon colour. Allow the Canary Yellow to fade as it reaches the Salmon so the two colours blend together. You may want to go back and adjust, perhaps adding more Salmon near the horizon or more Canary Yellow at the top. The beige tone of the paper will add a third warm tone to the sky.

Next, work on the figures and the boat. Some parts of the figures and boat are already coloured in Ivory Black and do not need colours added. Apply colours by adding only one layer of colour on each object, using medium to heavy pressure. The figures are in the distance and do not need any detail. Add Dark Grey to the left side of the boat where it is lighter. Add Steel Grey to all other parts of the boat. Apply Pablo White for two of the figures where light is reflected off their shirts, the small area on the boat near the windows, on the boom and on the bow where there is reflected light. Use Salmon for the figures' heads that are not already coloured with Black, and Steel Grey, Poppy Red and Crimson Red for their clothing where indicated in the picture.

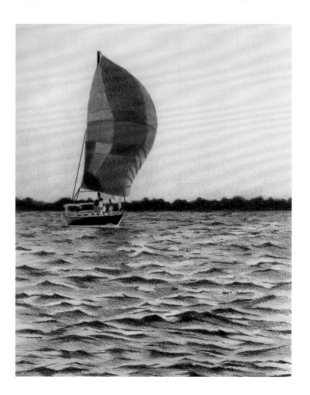

STAGE 5

Now you need to add the reflections from the boat's sail on the water. Perfectly calm water that is as still as glass will reflect elements like a mirror. If the water were still, we would see the sail reflected in its entirety. Moving water causes reflections to be broken up, so we only see a hint of reflection in the waves. Lightly add Crimson Red and Apple Green to the water just below the sail, letting the colour fade out and blend with the waves around the edges.

With a ruler and black coloured pencil, draw in some of the rigging lines attaching the mast and sails to the boat.

Now look at the Stage 4 image. Notice that the texture of the paper is showing through in the drawing. The final steps are to burnish parts of the drawing to smooth out the surfaces and disguise that texture.

Use a colourless blender pencil or a paper-blending stump (see page 20) to completely fuse the colours on the sail into the paper. (A paper stump fuses or smudges the colour into the paper more softly than a colourless blender pencil. It is also good for small areas.) Burnish each coloured area individually so that the colours don't run into each other and alter the shapes on the sail. If you're using a colourless blender, apply a heavy pressure to push the colours into the paper and create a smooth layer of coloured pencil. You'll notice the burnishing technique produces more vibrant colours. Repeat the burnishing technique on the hull, the cabin and railings and the figures.

Finally, burnish the row of trees in the background to give them a smooth surface, and some of the dark wave crests so they appear darker and shinier. Using a paper stump will help you burnish the dark crests and blend them into the lighter blue colours. To clean the paper stump between colours, rub it lightly on sandpaper.

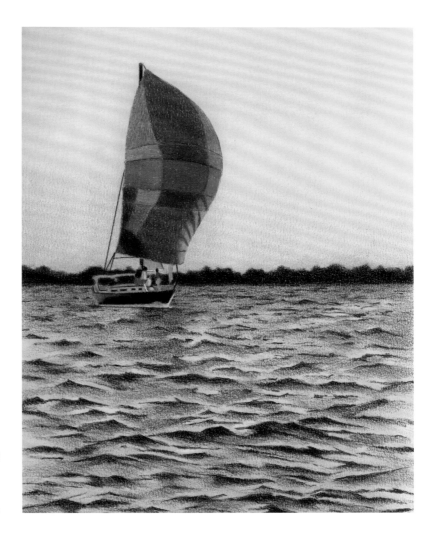

Use a paper blending stump to blend small areas. It will fuse colour into the paper and create an even surface.

A colourless blender pencil will blend the colours into the surface and fill in the tooth of the paper. The result is smooth, vibrant colour.

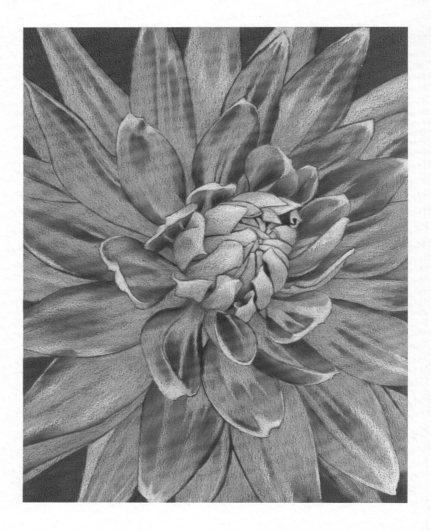

Flower Burst

In this project you will learn about juxtaposed colour and become more familiar with colour relationships. To create this vibrant dahlia, we will place colours next to one another, instead of layering them, and allow the viewer's eyes to mix them optically. We'll also explore composition, complementary colours and colour temperature.

PENCILS USED: PRISMACOLOR

White | Lemon Yellow | Blush Pink | Pink | Pomegranate | Crimson Red | Apple Green | Parrot Green

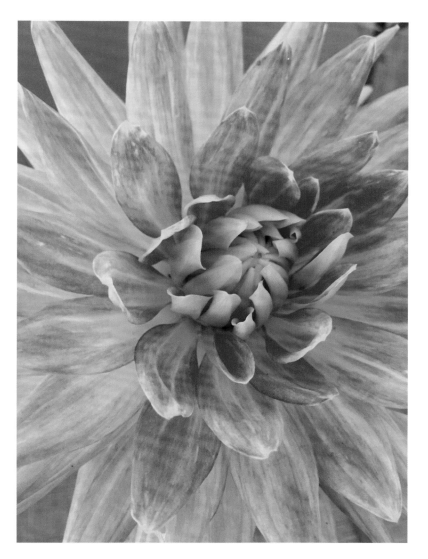

COMPOSITION

This photograph of a lively dahlia contains many interesting compositional elements and is composed of warm bright colours. Its vibrant, closely cropped composition is far more engaging than if had been placed centrally with lots of negative space around it.

Notice how the petals flowing off the page create movement and push the boundaries of the page edges. The shapes of the petals are made up of a series of curved and angled lines that give the flower depth, texture and detail. These lines flow outwards, leading the viewer's eye from the centre of the flower in all directions towards the edges, almost like a starburst.

While the petals flowing outwards give the composition energy, the folded petals close to the centre of the flower create a focal point. There is variety and repetition in the shapes, sizes, tones and colours of the petals. The negative space between them works with the positive spaces to balance the composition and create harmony, and the different shapes lead the viewer around the page. There is so much movement in this composition.

This dahlia radiates warmth and energy, so I chose red drawing paper as a base for the drawing. The coloured paper complements the drawing, and layers of colour show through one another. This drawing has an overall warm colour temperature (see page 15).

COLOUR SCHEME AND COLOURS

The photograph contains tones of yellow in the petals, but I wanted to emphasise the pink and red so I changed the colour scheme slightly. As an artist, you don't have to draw exactly what you see. A subject can be much more interesting if you give it your own creative ideas.

The complementary colours – blue-green in the background and the green at the centre of the petals – balance the warm red tones and cause them to pop. Complementary colours show more contrast when placed next to one another; warm tones come forwards, while cooler negative spaces stay quietly in the background.

Tip
Feel free to make changes to the colour scheme to emphasise particular colours, add contrast and balance out tones.

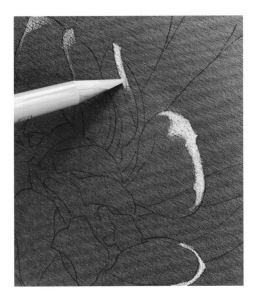

The first step after producing a line drawing is to add White and Lemon Yellow to the lightest areas of the petals.

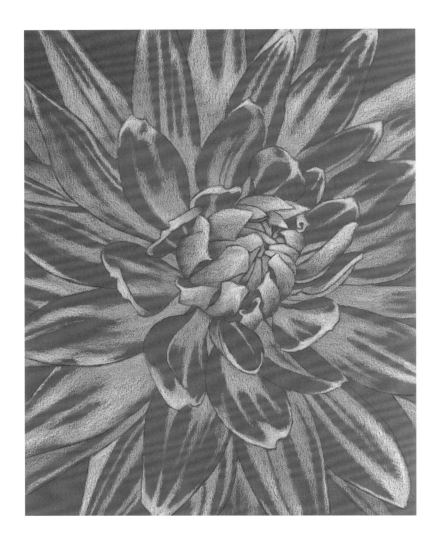

STAGE 1

Start with a graphite line drawing of the outline of each of the petals. With a complicated subject such as this one, it is sometimes easier to work out the drawing on sketch paper first, then transfer it to the final drawing paper when the all the erasing is finished and the shapes are correctly drawn.

Once the outline drawing is complete, you can begin to add details with coloured pencils. The dahlia has many petals and may appear intimidating, but just work on one petal at a time. Begin with the lightest value – white – and, using a light pressure, apply White to the tips of each petal, moving towards the centre of some of the lighter petals as indicated. Add White to some of the lightest areas of the folded petals, especially the folded petals in the centre. Also add White to the lightest areas on the edges of a few of the petals curling forwards.

Now, using a light pressure, apply the second colour – Lemon Yellow – to parts of each petal to show the striations. It is important to set out the structure and markings of each petal with the yellow pencil. Look at the reference photo and add Lemon Yellow to one petal at a time, working around the flower from the centre outwards. You don't need to get caught up in exactly recreating each petal – you can be creative. Colours can always be adjusted later.

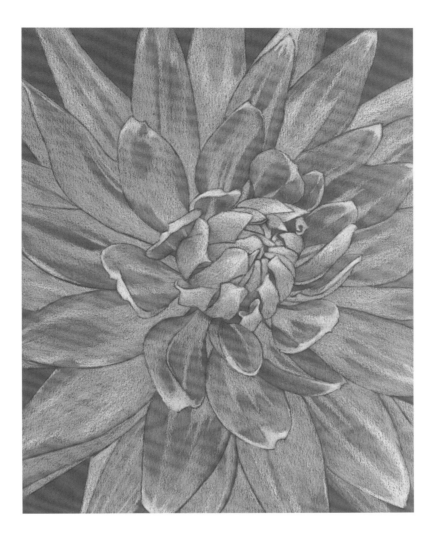

STAGE 2

Lightly erase some of the graphite outlines before adding more coloured pencil. In this stage we
will be using the two pinks – Blush Pink and Pink – to create the lightest tints of red within the petals.
Begin by adding Blush Pink next to or around the Lemon Yellow areas on each petal where the colour
changes from yellow to tints of red. Gently blend the edges together using a light pressure. Keep the
tips of the petals the lightest values because they are flowing outwards into the light.

Next add Pink. This will start to add dimension because Pink is darker in tonal value than Blush
Pink. Place the Pink next to the Blush Pink and some of the Lemon Yellow areas. Keep referring to
the photo while you create the colours of each petal. Apply Pink with a medium pressure to add more
tonal value towards the darker pink areas of the petal bases where petals overlap each other.

Now you have a good idea of how to juxtapose colours as opposed to layering. You are creating colour
and depth but placing colours next to one another and gently blending the edges together. Using a light
pressure makes it easy to change colours or lift or erase a colour.

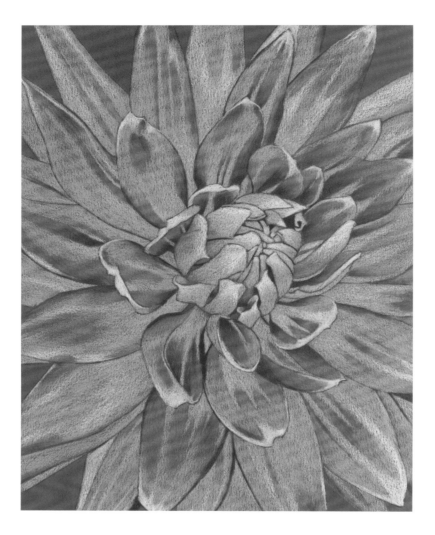

STAGE 3

At this point you have used four colours on the petals: White, Lemon Yellow, Blush Pink and Pink. Work a little more on building up the colours, using medium pressure in areas where the colours could be bolder, especially where they fold under one another. Continue blending the colours together until you are satisfied that you have captured the colours, tonal values and patterns of each petal.

Next you can begin to add a darker tonal value to provide variation in colour and tone. The colour Pomegranate will do this, and create depth and shadow on the petal edges. Apply Pomegranate to areas where the petals curl inwards, to the petals that tuck behind petals coming forwards, and also to some of the edges. Look at the reference photo to help you find these darker areas. I have also used Pomegranate to add contour lines on the edges of some petals to differentiate one from another.

Now we have used five colours, juxtaposed side by side. Notice how the dark Pomegranate placed next to the very lightest colours – White and Lemon Yellow – are making them pop forwards, and the drawing is interesting to look at because it has a good range of tonal values.

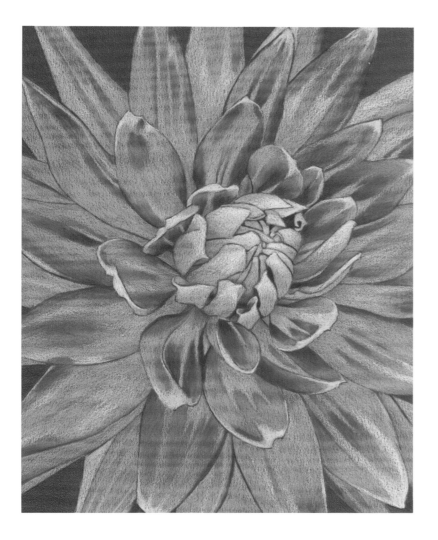

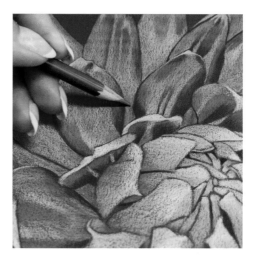

STAGE 4

Colours have been applied with medium pressure, allowing the texture of the red paper to show through all colours placed on the surface. This effect will create colour harmony throughout the drawing. Layer Crimson Red over some of the Pink and Pomegranate to give the flower warmer tones. Next, using light pressure, add Apple Green over Lemon Yellow just along the base of the petals where they meet in the centre of the dahlia and continue outwards, as shown below.

I chose Parrot Green for the background because it is a blue-green, which is the complement of the pinkish-reds, and also because it is a duller green that won't overpower the dahlia. Add Parrot Green to the background between the petals with a medium to heavy pressure, allowing some of the red paper to show through.

Now the drawing is almost complete. Add a little more White to the tips of the centre petals to make them pop forwards and stand out. Finally, readjust any areas that need more colour or blending until you are satisfied with your finished piece.

Apply Apple Green over Lemon Yellow and lightly blend outwards on the petal.

Colourful Greys

In this study we will learn how to create colourful grey tones by mixing various colours. Greys are used to complement bright colours and as restful places in the drawing.

Greys and neutral tones have many different purposes in art. They are essential for giving a drawing structure and depth, as without them our drawings would contain too many pure colours and appear overwhelming. Look around you and notice how many objects or areas contain greys or unsaturated colours. These neutrals are restful places in our environment and in our art, and a way of conveying both colour and tone.

Mixing neutrals and colours together

I like to create colourful greys by mixing neutrals and colours together. You might wonder why we can't just create a grey by mixing black and white. Well, this will produce grey but it will be a dull grey. And layering white coloured pencil over black coloured pencil will simply create a dull opaque grey. If you look at greys, you will see

Each neutral in the top row was created using two complementary colours. In the bottom row, the left square is a neutral made by mixing the three primary colours. The middle square is blue layered over violet. The right square is a dark violet and a blue layered over a grey coloured pencil.

they contain tints of red, blue or brown hues often mingled with purple, green or yellow, and they aren't dull at all. If you create greys by mixing colours, you will have more control over your neutrals and will be able to produce warm and cool greys in your drawings.

We also use grey tones and neutrals for creating shadows, backgrounds and to show distance. Shadows are actually blue combined with tints and shades of the local colour of the object or objects casting the shadow or creating reflections. The mixture of these tints, shades and blue will create colourful grey tones and neutrals (see Dynamic Skies, pages 40–41). As shadows recede, the amount of contrast will be reduced and edges will become softer. Colour, tonal value and texture diminish as an object or scene moves towards the background and become more neutral (for more information, see Layering a Landscape, pages 42–7).

Creating greys with coloured pencils

There are various ways of creating greys with coloured pencil. One option, which we learned about in Colour Theory and Tonal Value (see pages 14–17), is to combine two complementary colours. We reduce the intensity of a particular colour by adding its complement and neutralizing or greying the colour. As the intensity of a colour drops, it is referred to as being

Grey can help brighter colours pop forwards. When grey tones are juxtaposed or placed next to pure colours such as red or blue, these already intense colours become even more vibrant.

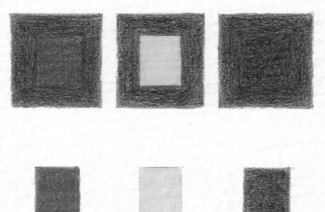

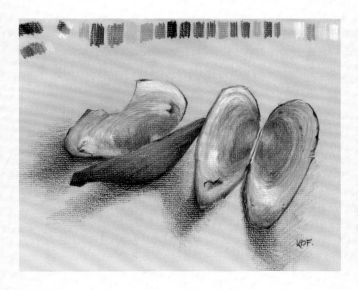

This illustration shows just how many neutrals can be used with some bright hues to create a combination of colour and grey. All the colours used are shown at the top.

Here I worked on grey paper and created the cellophane sweet wrappers with blue, violet, white and grey. The white highlights add liveliness.

greyed down. Creating greys by mixing complementaries of hues used within the drawing can add colour harmony. Another way is to layer the three primary colours, red, blue and yellow.

Alternatively, you can start with a grey coloured pencil and then layer other colours, such as blue or violet, over it to make it more interesting. Manufacturers of coloured pencils make a range of wonderful greys with various percentages of both cool and warm tones. The Glass Bottles project (see pages 64–9) uses a few warm greys in different percentages to create the illusion of clear glass.

In coloured-pencil drawing it can sometimes be tricky to create the right neutral or colourful grey with just colour. Pencil manufacturers produce greys in different percentages of tonal value that can help with finding the right mixture. You can dull a colour or colour combination with a grey pencil, or you can begin by drawing with a grey pencil and layering some colour on top. Adjust the colour temperature by using either warm or cool grey pencils. Find the correct degree of lightness or darkness by using grey pencils in different percentages.

We rarely see landscapes and objects with high chroma, so by controlling colour intensity with greys, you will produce realistic, true-to-life images.

I often ask my students to draw white objects, to see what colours and neutrals are contained within the shadows. Besides greys, the colours used are blue, violet, yellow and red.

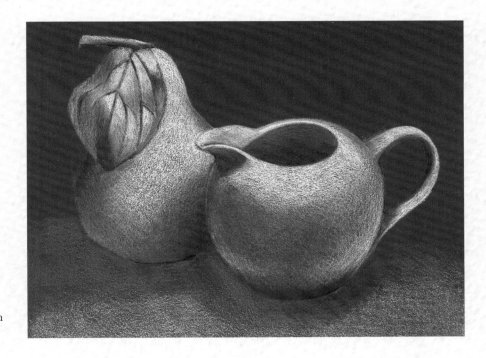

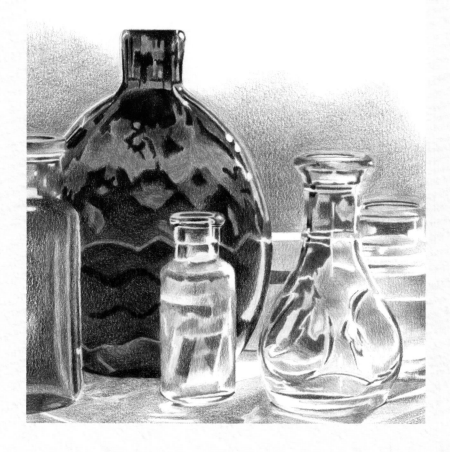

Glass Bottles

Here we learn how to draw transparent, opaque and coloured round glass objects. We will create the illusion of smooth glass by building line, shape, and light and dark patterns. This project will strengthen your ability to draw reflective surfaces and work with different ellipses to create rounded forms.

PENCILS USED: PRISMACOLOR AND CARAN D'ACHE LUMINANCE

Warm Grey 10%	Warm Grey 20%	Warm Grey 50%	Sky Blue Light	Caribbean Sea	Cobalt Blue Hue	Imperial Violet	Violet Blue

Indanthrone Blue	True Blue	Mediterranean Blue	Copenhagen Blue	Kelly Green	Genuine Cobalt Blue	Burnt Sienna 50%	Light Aubergine

Glass is a transparent material, its contours and shapes being formed by light and the reflections of objects surrounding it. In the previous projects we learned to construct solid forms and to create lights and darks by looking only at the surface of an object. But glass is a transparent grouping of abstract curves, patterns and distortions that are broken down into shapes of light, medium and dark tones. We don't just look at the outside of the glass; we look through it. We see the inside, outside and what is behind the glass all at the same time, not the material of the glass itself.

HOW TO DRAW REFLECTIONS

In the photo, the light comes from the window as the sun shines in from the right-hand side. The sunlight bounces off the bottles and creates reflections on the windowsill where they sit. The movement of sunlight on the glass makes bright reflections, and pure white highlights cause the glass to sparkle. Notice also how the light is distorted as it flows through the glass, forming abstract and fragmented shapes.

Reflected shapes can appear intimidating, though they are actually fun to draw. My students are usually nervous about tackling glass, but they always end up really enjoying the lesson. Start by looking for light and dark patterns that can be broken down into shapes, as the contrast between bright highlights and strong darks gives the glass its character and dimension.

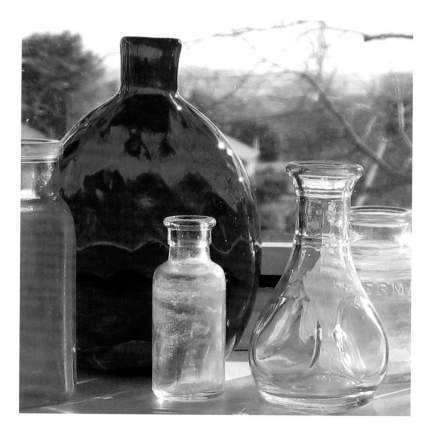

The clear bottles reflect the colours of the window frame and the outside scene ; they also reflect the blue tones of the blue bottle. The blue glass is also reflected in the shadow of the windowsill.

The round parts of the bottles and vases are made up of a series of ellipses that help each piece look three-dimensional. An ellipse is a circle that is viewed from a different perspective or vantage point so it appears flattened and foreshortened. The only time the ellipse at the top will be a complete circle is when you look straight down from above the bottle.

I selected a smooth white paper called Bristol vellum for this project. It's a good choice for drawing glass because it will accept layers of pencil and is excellent for detailed drawing. Before I began I studied my reference photo and each bottle as a subject. I evaluated the reflections and picked out the shapes and highlights that were most important. Seeing so many little shapes of colour can get confusing to the eye, so I have left some out. I have also left out the letters imprinted in the glass on the right. Notice the two left bottles have areas that are somewhat cloudy and not completely clear.

Drawing a vertical line down the centre of the bottle will ensure the sides are even, while horizontal lines will ensure the ellipses aren't lopsided. The circles on the right illustrate how the ellipses flatten near eye level and begin to open below eye level.

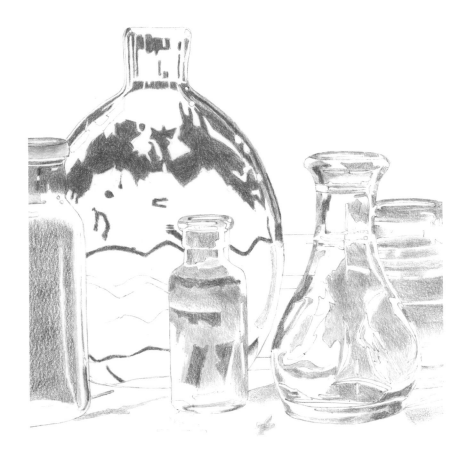

STAGE 1

Draw the outline of each bottle and, using horizontal or vertical guidelines, check that your bottles are symmetrical and ellipses are correctly rounded. If you look at my line drawing, you'll see that I have simplified and omitted some of the reflected shapes, particularly in the rounded bottle to the front right. Notice how the distorted shapes follow the contours of the bottles. The clear bottles are reflecting the colours of the window frame and the outside scene behind them. They are also reflecting the blue tones of the blue bottle. The blue glass is reflected in the shadow of the windowsill. Notice the two left bottles have areas that are somewhat cloudy and not completely clear.

The highlights will remain the white of the paper rather than being coloured with pencil. Take Warm Grey 10% and Warm Grey 20%, then colour the lighter tonal value areas of the clear bottles – use Warm Grey 10% in the lightest areas and Warm Grey 20% where the glass begins to darken in tone.

Put Caribbean Sea in the lighter blue areas of the bottles and on the blue reflections of the windowsill surface. Add Genuine Cobalt Blue to the darker blue areas of the bottles.

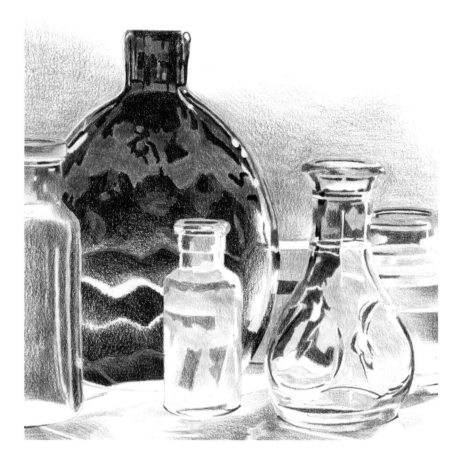

STAGE 2

Layer pencils with medium pressure to build areas of dark colours. Add Warm Grey 20% and Warm Grey 50% on the small area of window frame behind the bottles. Put Warm Grey 50% on the dark grey areas of the clear bottles and add Warm Grey 20% and 50% on the windowsill surface to create lighter and darker tones. Add Imperial Violet to the purple reflected areas on the blue bottle and on the clear bottle to the left. Colour the darkest areas of the blue bottle with Violet Blue. Vary the pressure and lightly apply some Violet Blue so it will fade into the other colours to be added later.

Notice that some areas of the bottles have distinct shapes with hard edges, and in other areas the colours have soft edges and are lightly blended together. Most of the lines and shapes are curved and contoured, following the shape of the bottles. Pay attention to changes in tone and form. Use your kneaded eraser to make sure lines on the edges and ellipses are crisp. You can also use the electric eraser to clean up sharp edges.

Using a light pressure, colour the background with Burnt Sienna 50%. We will layer colours to build up an illusion of the outdoors behind the bottles. The background will remain soft and out of focus as we don't want it to distract from the bottles, which are our main subjects.

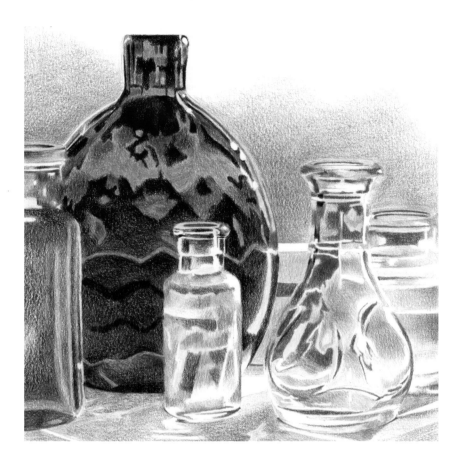

STAGE 3

Take the Indanthrone Blue pencil and work on the blue bottle. Add the colour to the darkest areas, working it into the Violet Blue. Also use it on the bottom edge, the stripes across it, the upper part and on the neck.

The blue bottle is mostly made up of warm blues (leaning towards violet on the colour wheel), but it also consists of cool blues (leaning towards green on the colour wheel). Lightly layer True Blue and Copenhagen Blue on the bottle to add warm blue tones. True Blue is the lighter of the two colours so add it to the lighter areas. Copenhagen Blue is darker and can be layered over the darker areas.

The clear bottles all contain reflected blue tones. Work on building these with the different pencils. The three bottles on the right have edges that are crisp and distinct. The bottle on the left is somewhat cloudy, so colours should be soft and blended except for the edges. The left bottle also contains the warmer blues, True Blue and Copenhagen Blue, reflected from the blue bottle.

The blue areas in all the bottles link the subjects together and create a colour harmony within the drawing. I have also added another layer of Warm Grey 50% to the windowsill to add more tone to the surface in which the bottles sit.

Add Light Aubergine over some of the grey areas in the rounded bottle to the front right. Lightly add Imperial Violet to the other two clear bottles on either side. These colours will add subtle warmth and variety to the grey tones.

Layer Mediterranean Blue over the Burnt Sienna 50% in the background. Apply the pencil with cross-hatch strokes to achieve a soft blended appearance.

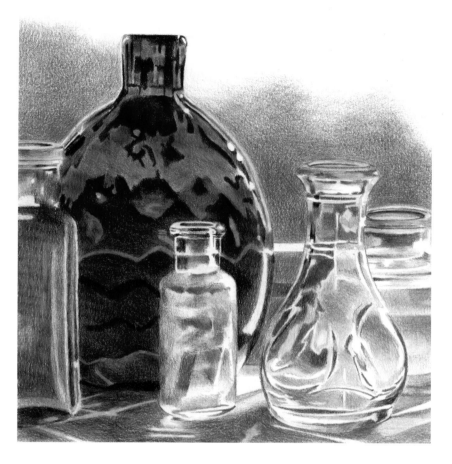

STAGE 4

To create the smooth appearance of the glass, take a stiff bristle brush or colourless blender pencil and burnish the blue bottle to remove the texture of the paper showing through (see page 20). Burnish carefully around the white areas so they don't become smudged with blue.

Now burnish the other bottles. Don't use the same brush on these areas – use different brushes for different colours, or sharpen colourless blender pencils to remove colour using the point. You can still make adjustments to the colours after you have burnished them.

I darkened the grey tones on the small area of window frame behind the bottles and made a few more adjustments to the shapes and highlights within the bottles. The contrast between the dark and light shapes and the smooth texture will help to give the illusion of glass.

Then I continued to build up shadows and reflections in the windowsill. I decided it needed to be darker in tone, so I added another layer of Warm Grey 50%, Light Aubergine and Violet Blue where colour and light are reflected through the bottles.

I also continued to work on the background by adding a layer of Kelly Green overall, then went back to areas of the foliage and, using medium pressure, applied more Burnt Sienna 50% and Mediterranean Blue. The upper part of the sky is coloured with a light layer of Sky Blue Light.

You can use the electric eraser to redraw white highlights that have been smudged or covered up. Check your edges and ellipses, then add contour lines on the edges to create depth and dimension.

Use a stiff bristle brush to burnish the surface and achieve the smooth texture of glass.

A battery-operated eraser can be used as a tool to redraw areas of white highlights that were smudged or covered up.

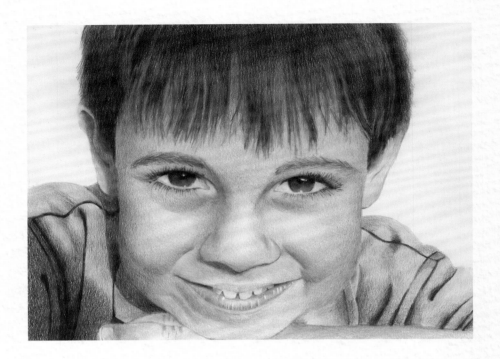

Portrait of a Child

This project will help you to understand facial planes and proportions and how to mould and shape the face and head. We will look at how to choose the correct skin tones and shadow colours. It will also help you learn how to add facial features and capture your model's personality.

PENCILS USED: PRISMACOLOR AND CARAN D'ACHE LUMINANCE

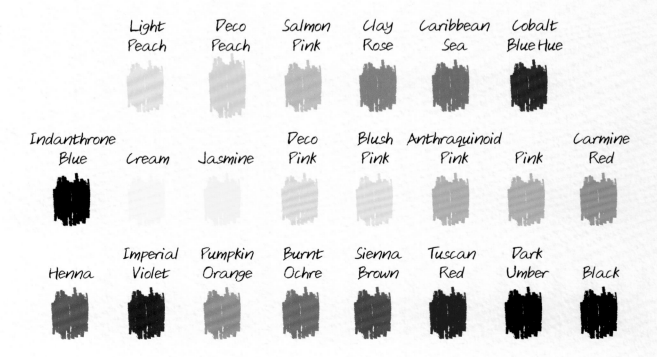

| Light Peach | Deco Peach | Salmon Pink | Clay Rose | Caribbean Sea | Cobalt Blue Hue |

| Indanthrone Blue | Cream | Jasmine | Deco Pink | Blush Pink | Anthraquinoid Pink | Pink | Carmine Red |

| Henna | Imperial Violet | Pumpkin Orange | Burnt Ochre | Sienna Brown | Tuscan Red | Dark Umber | Black |

Drawing people can be the most challenging subject when creating art. If you draw an object such as a flower or tree, it doesn't have to be an exact replica as the viewer will know that it's a flower or tree. But if you draw a person the proportions and features need to be exact, and you must capture their uniqueness, or they will resemble someone else.

HOW TO DRAW WHAT YOU SEE

Start by drawing the basic structure of the face. Get the scale and proportions right, and then break the face down into parts, so it will be less of a challenge. Practice is always helpful, so sketch from life if possible. Sit in front of a mirror and sketch a portrait of your image. Or you could sketch from photos, but make sure you choose quality photos with good lighting, in which features are easy to see.

The best way to begin is to simplify the shape of the head. Determine how oval or round, thin or wide it is. The head is a three-dimensional shape, so look at where light and shadow falls. Study features such as the eyes, nose, mouth, ears, cheeks and eyebrows, and view them as shapes. Shadow that is cast from a feature will help us learn about its dimensions and the size and shape of the object the shadow is cast on. Shadows and cast shadows also portray the contours of the face so that it doesn't appear flat.

Draw horizontal and vertical lines to get a sense of where features are placed and relationships between features. Measure distances – some people have eyes that are closer together or wider apart, longer noses or shorter ones. The face becomes recognizable and alive when the sizes and distances of the features are correct. There are a few basic guidelines for drawing the face, e.g., the mouth is one third of the way between the nose and the chin, although shapes and proportions vary with age, sex and ethnicity.

Measurements will also vary in a very young child. The eyeline will be lower than centre and a child's head is often wider and rounder than an adult's. As a young child grows, the head becomes more elongated and the eyeline moves up to the halfway point.

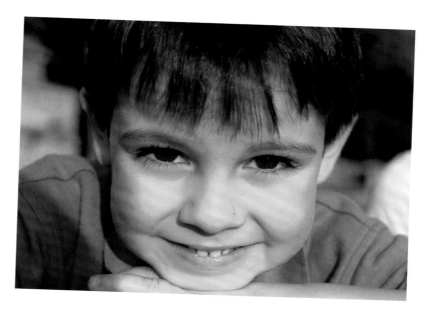

Tip
When drawing a portrait it is important to capture the personality and spirit of your model. A good expression, lighting, pose and composition are all important.

Horizontal and vertical lines help to position features.

I have selected a photo of my nephew Timothy for this project. I like the frontal view, and the good lighting enables me to see all the features, shadows, cast shadows, lines and planes of his face. Timothy is leaning downwards on his arm, so the proportions of his facial features are slightly different than my diagram of face guidelines. I chose a smooth paper, and kept pencils sharp and strokes consistent when layering, to build the smoothness of skin. All the pencils used in this project were Prismacolor, apart from Anthraquinoid Pink (Caran d'Ache Luminance), because I couldn't find the colour I wanted in the Prismacolor range.

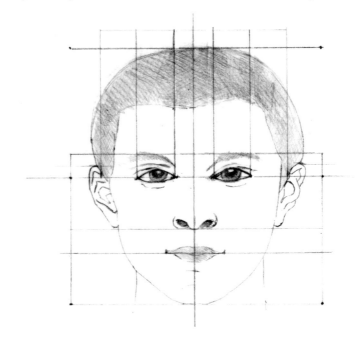

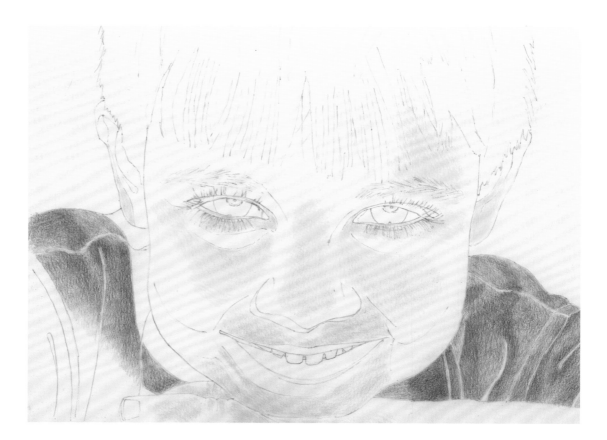

STAGE 1

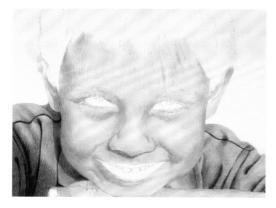

Let's start with a sketch, drawing Timothy's facial features as well as denoting facial planes, such as dimples and recessed areas around his eyes, teeth and small creases in his lips. Also draw in small lines to indicate the structure of his hair and placement of his eyelashes, eyebrows and teeth. Make sure the proportions are correct and the drawing has a good likeness.

Now we can build up his skin tones by laying the palest colour, Light Peach, on his face, keeping minimal pressure on his nose and cheeks where the light is highlighting those areas. Use Deco Peach to add medium tonal values and pinker areas in his skin. Then add Salmon Pink to darker areas, such as around his eyes, under his nose, around his cheeks, on his arm and inside his ears. Notice how I have also built up the skin colour under his hairline, eyebrows and eyelashes. Use the warm purplish Clay Rose to create shadow and structure on Timothy's skin. Notice how the blue tones in this colour echo the blue cast shadow on his shirt.

Next we'll work on Timothy's shirt using Caribbean Sea, Cobalt Blue Hue and Indanthrone Blue. Use Caribbean Sea to show the lightest areas and layer Cobalt Blue Hue over areas where the fabric folds away from the light. Increase pressure to build colour in the darker areas, then add Indanthrone Blue to the darkest areas and creases in the fabric.

Tip
Start with the lightest colour to work on skin tones then build up colour. You will need to layer several colours to create the natural look and glow of skin.

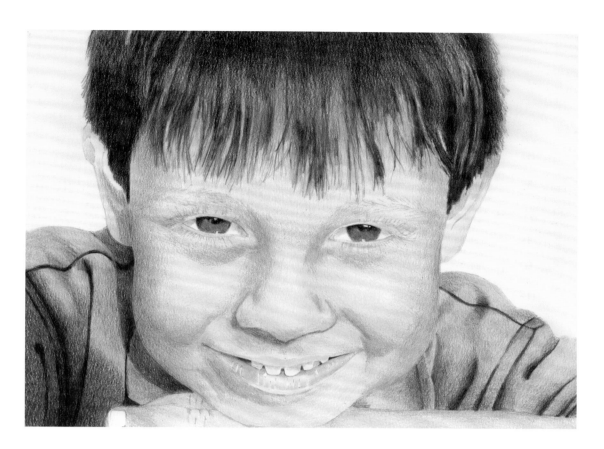

STAGE 2

We'll develop Timothy's features before going any further with the skin tones, so everything starts to work as a whole. Draw the strands of hair with just one colour, Dark Umber. Vary the pressure and how you make your strokes – darker and closer together on the sides and top of his head, lighter and more spaced at the front. Keep strokes light and random, and notice how parts of the fringe form clusters. Develop the strands gradually.

Next we'll focus on the eyes. First, draw in the white highlights and then work around them. Pupil colours are darker at the top, where they are shadowed by the upper eyelid. Build colour with Black and Sienna Brown – Black for the pupils and on top of the irises. Shadow the whites of the eyes with a light application of Clay Rose.

Now we'll work on the mouth and teeth. Beginning with the mouth, the lightest colour for the highlighted areas on the bottom lip is Deco Pink surrounded by Blush Pink. Use Anthraquinoid Pink for the darker areas on the bottom lip and behind the teeth. The top lip is thinner and lighter, so use Blush Pink here. Dark areas in between the lips and in the mouth are Tuscan Red with a little Indanthrone Blue. For the teeth, lightly apply a mix of Blush Pink and Clay Rose to the shadowed areas, and add Cream to the lighter areas.

Finally, erase any pencil lines that you made in Stage 1 if they are still visible (see inset).

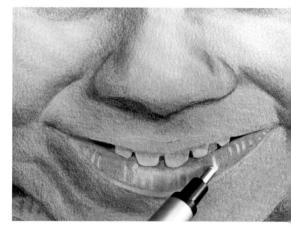

I gently erased the pencil lines I drew for placement in the initial sketch in Stage 1 using a pen-style eraser, which is helpful for removing small areas.

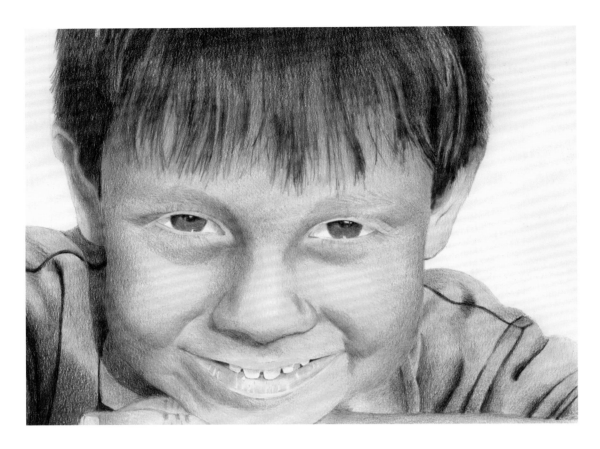

Tip

Skin comes in many different colours and shades, and is also influenced by the lighting and colour temperature.

Examples of various skin tones in coloured pencil. Experiment to determine which ones you need.

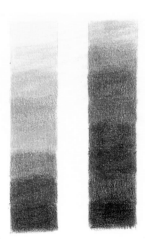

STAGE 3

We have developed the base of colour for hair, eyes and lips, so now we want to adjust and build the skin tones. We'll do this before finishing the hair, eyes and lips because it's easier to build the planes without the small details.

For the darker and reddish tonal values on the forehead under the strands of hair, blend Henna and Pumpkin Orange. Add Clay Rose to the shadowed areas on the ears. Use Carmine Red for the bright red insides of the ears and corners of the eyes. Add a light layer of Cream to the whites of the eyes.

Build up depth and shadows by layering cool Imperial Violet and warm Burnt Ochre – I have layered each colour twice. I like the little trick of alternating layers of cool and warm to create both colour and dimension. The Imperial Violet also works as a shadow for the light reflecting off Timothy's shirt onto his face. You can see where the deepest shadows are placed – under the eyes, between the eyes, on the sides of the face and under the nose. These shadows are also around his mouth and cheeks, forming dimples as he smiles. Keep in mind that you are fashioning a rounded subject.

Take the Pink pencil and add pink tones to his cheeks and left side of his nose. The Pink will add warmth to the skin tones.

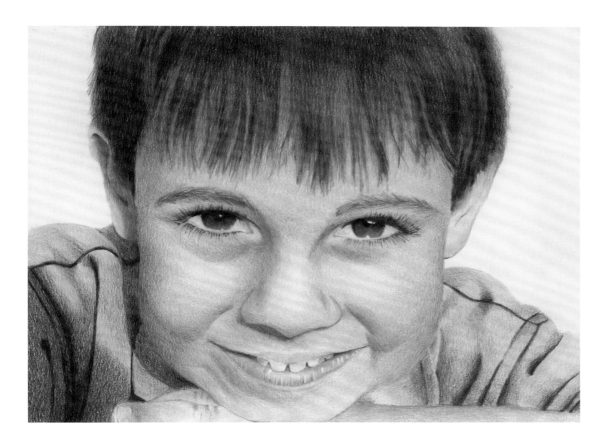

STAGE 4

Now we can return to the hair, lips and eyes, adding eyelashes and eyebrows as well as making any final adjustments to skin tone and shadow.

Let's add some other colour and tones to Timothy's hair. Use Sienna Brown for the lighter parts. Because we lightly layered the Dark Umber, the lighter brown will be visible on top. For depth and dimension, add both Tuscan Red and Indanthrone Blue to the sides, top and front areas. The warm and cool tones of the red and blue will give the hair a more natural look.

Lightly add black flecks to Timothy's eyes with Black and use Tuscan Red to add dimension and dark tonal value to the irises. Take Dark Umber and carefully draw in his eyelashes to make them look natural. Eyelashes vary in length, are slightly curled and tend to grow in clumps. As you draw the lines, let them fade at the ends so they don't end abruptly.

Draw the eyebrows by looking at the pattern of the hair growth. I have added each line individually but kept them light and soft at the edges. Keep your pressure light to medium as you build the hairs.

Now build up colour on the mouth. I have added more Anthraquinoid Pink and lightly added Henna to the striations in his bottom lip, letting a few white highlights remain. Lightly darken areas between the teeth where they are pressed into the lip.

Finally, we need to add an overall golden glow to Timothy's face, so we'll use the warm muted yellow of Jasmine. With a light pressure, glaze most areas on his face with this colour.

Tip
The soft lead in Prismacolor pencils is excellent for blending, so you can accurately depict skin tones.

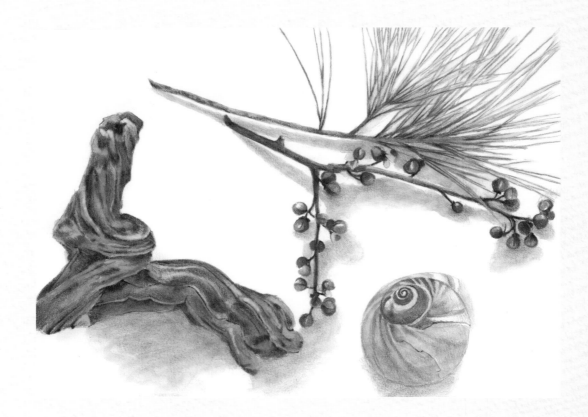

Nature Study

In this project we will learn how to use watercolour pencils. You can use watercolour pencils with coloured pencils and even add water to them to create paint. They allow you the freedom to work loosely and let colour flow quickly. Treat them as a portable paint palette and experiment with drawing outside or sketching while travelling.

PENCILS USED: CARAN D'ACHE SUPRACOLOR AND DERWENT INKTENSE

Golden Yellow	Golden Ochre	Brown Ochre	Venetian Red	Burnt Sienna	Umber	Vermillion	Scarlet

Chilli Red	Shiraz	Olive	Spruce Green	Dark Green	Blue Jeans	Periwinkle Blue	Grey

OTHER MATERIALS NEEDED

- Soft No. 8 round watercolour brush (or a size of your choice)
- Hot-pressed 140 lb (300 gsm) watercolour paper
- Small container of water
- Paper towel or damp sponge to blot the brush

Art provides us with the ability to capture moments in a sketchbook or use those sketches as a reference for a more detailed piece of artwork later on. Drawing nature and drawing outdoors are ways to help you remember a time and a place. You can take your sketchbook and pencils anywhere, and it doesn't take long to create a few quick sketches. Practising often, even just for short periods, is an excellent way to improve your work.

When learning to sketch, spend time planning out some rough ideas first. Take a good look around you until you see something that captures your eye. It could be a grouping of trees, some birds or an interesting plant. Once you've decided on a subject, make a few small pencil or ink sketches to help you plan your composition. I often take photos of my scene or subject if I want to refer back to it or finish it later. The important thing is to have fun and not worry so much about the outcome, just the practice.

A good way to begin is by observing your subjects, studying their shapes, structure, textures and markings. Good lighting is helpful to show the highlighted areas, colours and shadows. I start by developing a sketch in pencil so I can erase areas if needed. When my sketch is complete, I add washes of colour using watercolour pencils and adding a little water on a brush to move colour around. The watercolour pencils allow me to create base colours on the subjects, which is a helpful way to quicken the drawing and colouring process.

For this project I grouped a few natural objects with different characteristics and textures – driftwood, seashell, bittersweet berries and a sprig of pine – and placed them on a white surface so I could easily see shadows.

CHOOSING MATERIALS

I chose hot-pressed (smooth) 140 lb (300 gsm) watercolour paper, which is measured in weight per 500 sheets. The heavier the weight, the more water it can withstand and the less it will buckle. We're only adding minimal water, so this weight of paper will be sufficient.

For this project I needed to use water-based pencils, not wax-based. There are many different brands and types of watercolour pencils, but the ones I chose work well both wet and dry, flow easily and have a nice range of colour.

Shell study (above) in lead pencil with tones using black and white watercolour pencils.

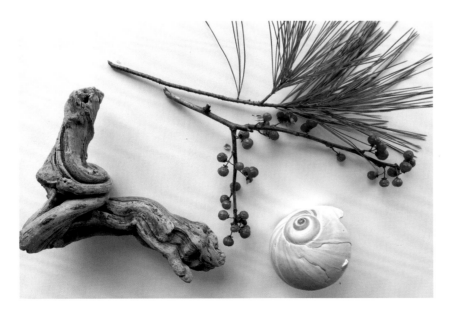

Tip
Watercolour pencils can be used separately or combined with ordinary coloured pencils. I like to combine them and use the watercolour pencils to create quick washes or underpaintings.

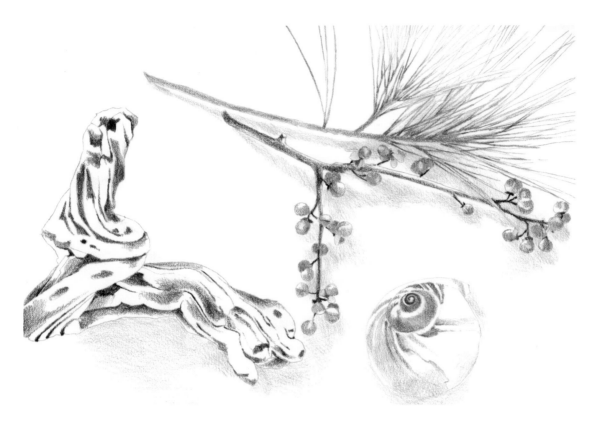

Move water around with the tip of the brush and work on one area at a time. Here, I allowed the Grey and Burnt Sienna to blend together softly.

STAGE 1

First, make a sketch of the objects, adding in characteristics and markings for each. Take the time to draw individual berries and groupings of pine needles.

The next step is to add a base layer of dry watercolour pencils to start developing the colours and tones of the subjects and shadows. Dry watercolour pencils are applied just like wax coloured pencils, but bear in mind that watercolour pigment can deepen and brighten considerably when water is added, so it's best to apply them with a light pressure at this stage.

Begin with Umber and draw all the darkest parts of the driftwood – the indents, dark markings and shadowed areas. Also use Umber to colour the bittersweet berry branch. Work on the berries, using small amounts of Golden Yellow and Burnt Sienna on the few little shells. Use Vermillion and Scarlet on the berries, leaving some of the paper showing for the white highlights.

Colour the sprig of pine bark Olive and Brown Ochre. I used Spruce Green for the pine needles, adding lines from the branch outwards. I have left some pencil lines to show how I drew and overlapped the needles.

Add bits of Grey and Burnt Sienna to the seashell to start defining the spiral pattern and darkest-toned markings.

Sketch the shadows with a light layer of Blue Jeans.

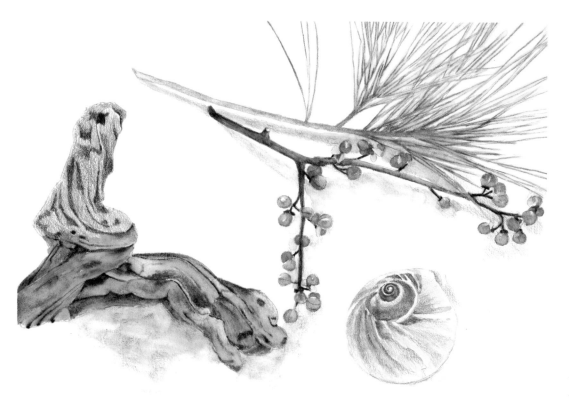

Tip
Test your pencils
on a scrap sheet of
paper first to see
what colours you
will end up with
when you've added
water to them.

STAGE 2

Use Brown Ochre for the lighter areas of the driftwood, paying attention
to the crevices and where the wood turns away from the light – the tonal
values will be darker in those areas.

Draw colours and patterns on the shell with Golden Ochre, Venetian Red
and Periwinkle Blue. Carefully observe the delicate swirls and colours to
define the shell's characteristics. Add a light layer of Periwinkle Blue to the
shadows to give them dimension and colour.

Next, we'll add water and create 'washes' of colour on each object. Dip
your brush in water and blot it on a paper towel or damp sponge to remove
excess water so that it won't puddle on the paper. Then apply the brush to
the objects. The water will dissolve the pencil pigment and you'll be able to
gently blend colours into one another. Clean your brush and reapply clean
water when you move to a different-coloured area. Use the point of the
brush to apply water to smaller areas such as the pine needles, berries and
thin branches. A very small brush would be ideal for this.

You can add more watercolour pencil while the paper is wet and then blend
colours, or you can blot colour with a paper towel to remove it. Pull water
outwards to soften edges so they don't stop abruptly. This is especially
helpful for blending the edges of the shadows into the background.

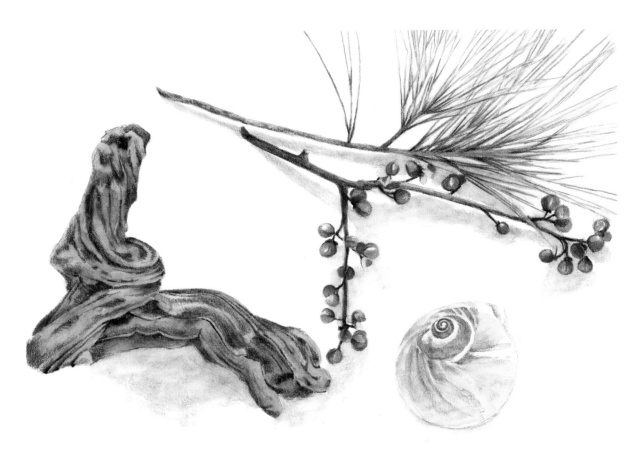

STAGE 3

Allow colours to dry before adding subsequent layers of colour. It should only take a few minutes, or if you're painting indoors, you can dry them quickly with a hair dryer on a low setting.

Now we'll develop the forms by adding more colour on top of our base colours to create texture and detail. To establish three-dimensional forms, you need to create light, medium and dark tonal values.

Add more Olive and Brown Ochre to the pine branch to accentuate its characteristics. Then use Dark Green to add definition to the base of the pine needles where they grow from the branch. I lessened my pencil pressure where the needles become lighter and softer as they flow outwards.

Brighten the berries with additional colour. I used Scarlet as well as two darker toned reds, Chilli Red and Shiraz, to create the illusion of depth where some berries are beneath branches or other berries. Add Umber to the berry branch, alternating dark and light areas.

Tip

It's important to allow colours to dry before adding another layer, otherwise colours can mix and create a 'muddy' look rather than vibrant colour.

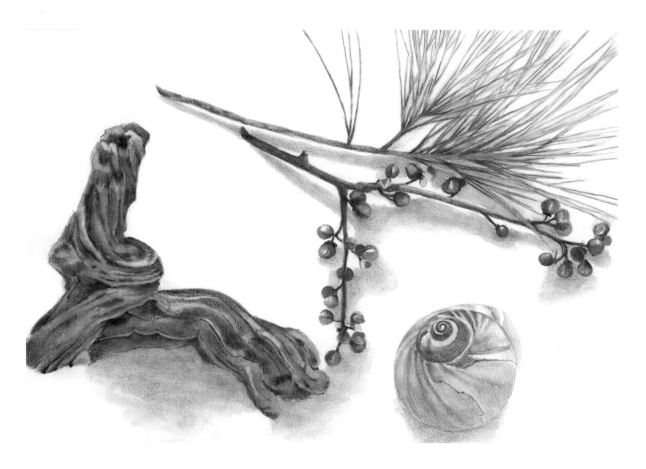

STAGE 4

Continue to add detail by adding colour and watery washes. I used the watercolour pencils dry for some of the more intricate parts, but you could also dip the points in water and then draw with them.

Build up colour and tonal value in the driftwood using dry watercolour pencil in Golden Yellow, Brown Ochre and Umber to show rough texture. I also used a battery-powered eraser to create highlights on areas that are closest to the light.

Continue to work on the shell, adding more colour and Grey for shadows where the shell turns away from the light. I deepened the tones around the small spiral at the top to give a strong contrast between light and dark.

It's worth spending some time on the shadows. I linked most of them compositionally to pull the objects together and help the viewer's eye move between them. The colours of an object will be reflected in its shadow, so I lightly added Scarlet to the shadows behind the berries, where they reflect light, and added Brown Ochre to the shadow beneath the driftwood. You can also add colour to the shadows of the pine branch and berry branch. Colourful shadows are much more interesting that grey shadows.

Tip
I like to blot my brush on a damp sponge to remove excess water so that it won't puddle on the paper.

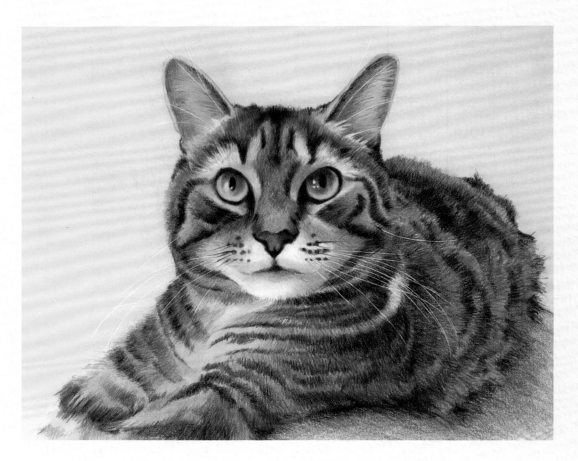

Portrait of a Pet

Coloured pencils are ideally suited to creating a beautiful, realistic drawing of a pet, as they can capture the texture and subtle details of fur. In this project you will learn how to simplify colours and patterns in fur, and use strokes to show its direction of growth. You will also discover how to draw three-dimensional eyes and use the sgraffito technique to depict whiskers.

PENCILS USED: CARAN D'ACHE PABLO

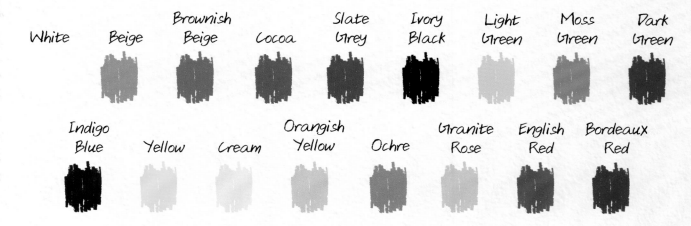

White Beige Brownish Beige Cocoa Slate Grey Ivory Black Light Green Moss Green Dark Green

Indigo Blue Yellow Cream Orangish Yellow Ochre Granite Rose English Red Bordeaux Red

For many years I have been drawing coloured pencil pet portraits for clients. I always work from photographs, as it would be difficult to have the pet sit still for the period of time it takes to draw them. I like to have a few reference photos, and if possible I like to meet the pet to study their characteristics. It's very important to select a photo that has good lighting, captures the personality of the pet and possibly has an interesting angle or pose.

The pet model I chose for this project is a family member's cat named Cato. I am already familiar with Cato and his characteristics, so that made it easier for me to draw him. I liked this particular photo of him because it depicts a little of his personality. It also provides a good close-up view of his facial features and shows the variations of colour in his fur.

It's very helpful to have a little understanding of an animal's physical anatomy. Knowing the basics of how their bones and muscles connect will help when drawing their physical structure. Look at their body parts – the head, legs, ears and tail – and notice how and where each part connects to the body. You also need to be able to convey the illusion of skin and fur. Notice their different textures: skin can be smooth, sagging or contain wrinkles or rolls; fur can be short, long, curly or wiry. To draw fur requires patience, paying attention to detail and building strokes and layers. Strokes need to be random so that hairs appear to grow naturally.

FOCUSING ON THE EYES

In our drawing, we want to focus on Cato's facial features, in particular, his eyes. The eyes are an animal's most important feature, as they capture their personality and soul, and will captivate the viewer so they look further into the drawing. Cato has beautiful green eyes so we're going to accentuate the colours to make them appear bright and lively. Highlights in the eyes are reflections of the surrounding environment. Highlights and variations of colour will help the eyes appear three-dimensional and glassy.

CHOOSING MATERIALS

It is important to choose a paper that will complement the pet. I could have selected a white paper, but it would have taken much more time to cover with colour. Instead I opted for a beige 100 per cent cotton smooth drawing/printmaking paper, which has a soft finish and isn't overly textured. The cotton finish holds the pencil nicely and beige is one of the colours in Cato's fur, so letting the paper show through did some of the work. It also serves as an attractive background colour to complement the drawing.

I chose Pablo coloured pencils for this project because they're made of a firm oil-based lead that doesn't crumble. They are perfect for drawing fine lines and details in fur and are also easy to erase or lighten with a kneaded rubber.

When drawing a pet portrait, it's much easier to work from a good photograph that is well lit.

Use a medium to hard pressure to emboss lines for the whiskers so that they will remain the colour of the paper. I have added Ivory Black to demonstrate this. Notice I have also put highlights in his eyes so I will know their position when I draw them.

STAGE 1

Begin with graphite pencil and draw Cato's outline, facial features including whiskers, and the striped patterns on his fur. Take time to observe the proportions, features and patterns in order to draw them correctly. Notice the direction in which the fur moves to form the body contour and look for changes in direction. Use a light pressure so you will be able to correct mistakes.

When the sketch is complete, use an embossing tool to indent lines in the paper for each of Cato's whiskers (see close-up, left). If you don't have an embossing tool, you can use another bluntly pointed object such as a thin knitting needle.

Using Ivory Black, block in the black stripes of the fur and Cato's other facial features. This will serve as the foundation for the other colours to be added later. It requires patience to lay in all those dark stripes and areas, so be sure to take your time. Next, add White to Cato's mouth, the highlights in his eyes, above and under his eyes, and where the light hits his fur under the whiskers as well as on the edge of his right leg.

Keep your pencil strokes smooth to make the eyes appear rounded and glassy.

As I mentioned earlier, eyes depict an animal's personality so it's important to position the highlights correctly to ensure they look natural. Too many white highlights will look unnatural, which is why I chose only the largest. Draw these in White, then add the other colours. Start by lightly laying in Yellow along the bottom rounded edges and then continue with Light Green, working it into the Yellow. I used Moss Green to transition light colours to dark colours. The tops of the eyes will be darker because they are pushed back and shadowed by the lids. Use Dark Green and Indigo Blue for the darker areas in the upper part of the eyes.

STAGE 2

Having blocked in the black stripes and white areas, and worked on the eyes, you have a good foundation for your drawing. Now you can start adding details.

Cato has beige and yellow tones under parts of his fur, on his face, chest and front legs. Use Cream, Orangish Yellow and Ochre on these areas to build the undertones. Blend the colours on his face where the hairs are short and smooth, and use directional strokes on his paws where the fur is longer.

For Cato's nose and nostrils, use a medium pressure to apply English Red and Bordeaux Red within the Ivory Black outline. Lightly layer the two colours around and above the tip of his nose, then very lightly apply Bordeaux Red under his mouth.

The colours we're using for Cato's ears are Granite Rose, Beige, Brownish Beige, Cocoa, Orangish Yellow, White and Ivory Black. Start by applying strokes of Granite Rose to the centres, using a light pressure to build up colour. Layer Beige and Brownish Beige next, paying attention to the outwards direction the fur is growing and allowing the base colours to show through.

Add Cocoa and Ivory Black to the dark edges of the fur on the inner ears, and combine lighter and darker colours by interlacing the hair strokes. All the pencils are lightly layered, so you can add a few strokes of white on top to show lighter hairs. Notice the edges of the ears curve inwards and the darkest areas are closest to the centre of the head. Place Orangish Yellow and White on the very edges around the dark area.

When colouring the cat's ears, draw the strokes in the direction the hair is growing, and apply them carefully so you keep the impressed lines for the lighter hairs.

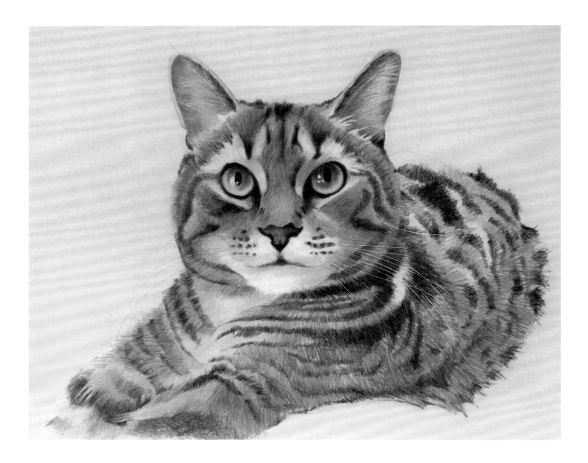

STAGE 3

The next step is to add Beige and Cocoa to the fur, giving depth and dimension to Cato's head and body. Begin with the lightest colour, Beige, on his face, and add a little to his chest, paws and body. Layer Cocoa over the Beige, allowing some of the Beige to show through in the lighter areas. It's almost impossible to draw every hair, so I like to work on small sections at a time. Use the black patterns as a guide when placing the different greys.

Keep your pencils sharp to create the look of hair strands and make sure your strokes follow the direction of the fur and the contours of his body. The hairs on Cato's face are shorter and smoother, while the hairs on his body and legs are longer. You'll see that I have added rough strokes of fur on his body, which I'll refine later. Also notice where the paper shows through, serving as a base layer of colour for the drawing.

The pencils are soft and can be smudged into lighter areas as you work with them, so I often put a sheet of clean paper under my drawing hand to avoid accidentally smudging them. But the pencils are easily cleaned up or lightened by dabbing areas with a kneaded eraser.

Tip
You don't have to draw every cat hair, just strokes that will be combined with other colours to give it a natural look.

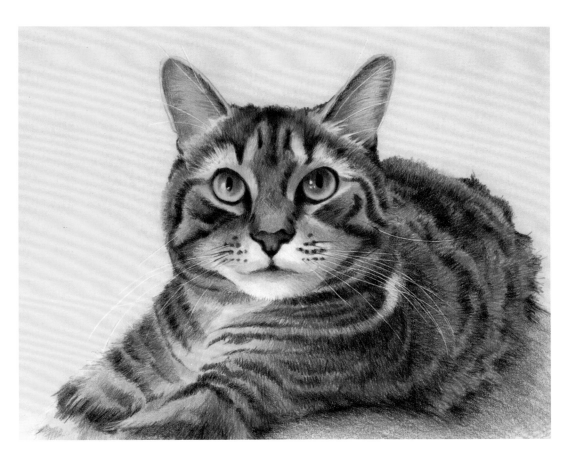

STAGE 4

Now take the last fur colour, Slate Grey, and layer in the darker areas to give Cato yet more dimension. Add short strokes of Slate Grey around the black areas above his eyes and on the sides of his cheeks. Then add it to the darker areas on his back and right side. The rough strokes will allow the other layers of colour to show through. Note some parts of the fur are almost scribbled and don't have to be as smoothly layered as other project drawings.

Refine any areas that need attention. You may need to adjust the eyes now that all the fur colours are layered on his face. Perhaps make them more shadowed at the top, so they appear round. I have added strokes of White to feature his eyebrows.

Use Cocoa and Ivory Black to draw in a shadowed area underneath Cato, so that he appears to be sitting on something. I chose these two colours because they subtly blend with Cato's fur.

Finally, add White to the grooves created for his whiskers. Make sure the pencil is very sharp, then gently fill in the paper grooves. Work from the inside outwards and let the pencil lighten at the tips of the whiskers. Be careful not to press too hard, otherwise the point will break off, and don't allow the pencil to stray out of the groove.

You now have a lovely pet portrait and are ready to practise with your own pet!

Take a sharp white pencil and gently fill in the grooves you created with the embossing tool.

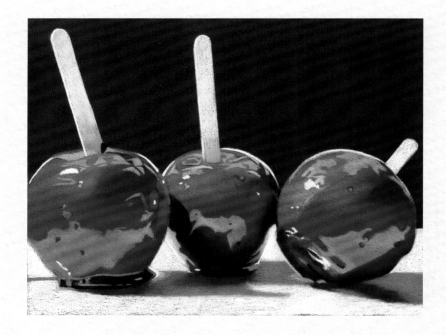

Toffee Apples

In this project we will learn how to combine coloured pencil with solvent to create a more painterly effect. Solvent melts the wax binder in the pencil, eliminating pencil strokes and smoothing out the surface of the drawing. This technique also helps make the layering of colours much quicker.

PENCILS USED: PRISMACOLOR AND CARAN D'ACHE LUMINANCE

Cream Beige Blush Pink Spring Green Nectar Clay Rose

Process Red Cloud Blue Pink Ultramarine Pink Carmine Red Crimson Lake Crimson Red Poppy Red

Scarlet Lake Tuscan Red Black Grape Luminance White Blue Violet Lake Indanthrone Blue

OTHER MATERIALS NEEDED

- Odourless mineral spirits or turpentine
- ¼in (6mm) soft flat synthetic paintbrush
- Optional: ½in (12mm) soft flat brush or soft round brush
- Paper towels

ADVANTAGES OF USING SOLVENT

Adding a little solvent to a layer of coloured pencil with a soft bristle brush will break down the wax binder and allow you to move pigment around the paper. Solvent fuses the colour into the paper and the layers of pencil become thick and opaque. After it dries, you can apply more layers of coloured pencils and solvent if needed. I enjoy this technique because I can create rich, vivid colours and make my drawing look more like a painting. It also means I can apply the coloured pencil more quickly and less evenly because I will smooth it out at a later stage.

CHOOSING THE RIGHT MATERIALS

The best pencils to use with solvent are those that have a soft wax base and blend more easily than harder pencils. Practise with different brands to determine which will work best for your type of drawing application.

Choosing the right paper is also a factor. I like a sturdy paper or board that will withstand layers of colour and solvent, and won't buckle or disintegrate when solvent is added. I often choose a sanded paper surface because the rough tooth holds the pencil, blends and builds colour quickly, but keep in mind it will also wear down the pencils faster. For this project I chose a warm red-toned sanded board, as the red background complements the apples so I could allow it to show through in some areas.

A word of warning when using solvent: even though it is considered odourless or natural, all solvents release some toxins into the air. We will only use a small amount of solvent for this project, but be sure to work in a well-ventilated area. Odourless mineral spirits and natural turpentine are the safest to use.

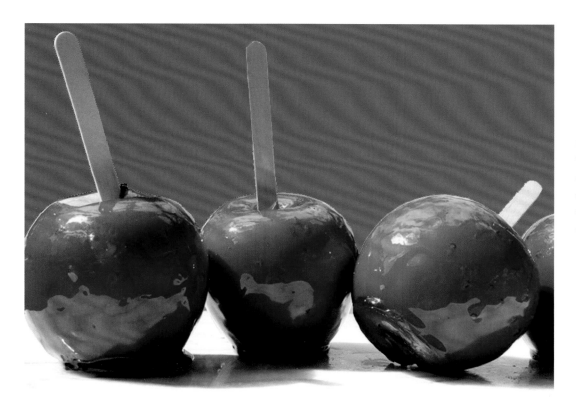

Tip
It's a good idea to practise working with solvent and coloured pencil on a scrap of paper first to understand the results.

STAGE 1

I have drawn my outlines using a white erasable pencil so they will show on the red-toned paper. Sanded paper helps the pencil to blend and layer much easier but it will wear down the pencils faster. I test my colours on a scrap of the same coloured paper I am working on, as colours will appear different on a dark-toned surface such as this red.

Colouring the toffee apples will be similar to the Glass Bottles project (see pages 64–9), as we will be drawing shapes that are reflected in the apples. But as these shapes are opaque, rather than transparent, we will also round them with tonal values. And remember, you don't have to be very particular when laying down colour, because the solvent will smooth everything out later.

I begin by drawing the white highlights in the apples, where the light is hitting the fruit's shiny surfaces. Colour the reflections at the top of the apples with Blush Pink, Pink and Ultramarine Pink. For the larger reflections on the lower half of the apples, use Clay Rose and Ultramarine Pink, Blush Pink and Carmine Red.

Tip
Sanded paper is a good choice when you want to lay down colour quickly.

Now work on the sticks. First, apply Cream where the light is catching the side edges of the left and middle sticks. Add a bit of Carmine Red to the bottom side edge of the middle stick. Colour all three sticks with Beige but as you near the bottom use Nectar, Clay Rose and Spring Green on the left stick, as shown. The bottom of the middle stick is coloured with Nectar and Clay Rose and use just Beige on the right stick. For the shadowed area under the apples, use Blue Violet Lake and Black Grape.

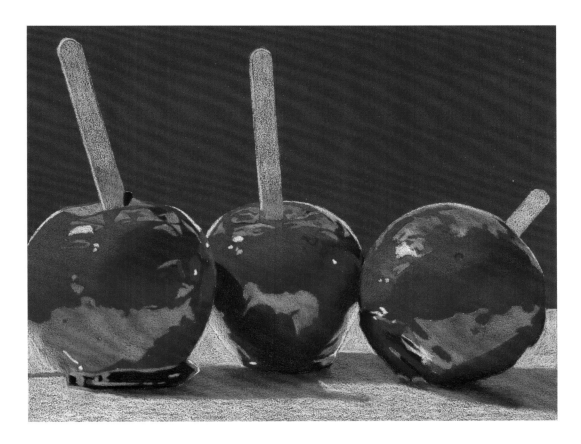

STAGE 2

Now the reflections are drawn, you can add red tones to the apples around the reflected shapes using the picture as a guide. You'll notice that the red-coloured pencils are softer and crumble more easily than other coloured pencils. We will be blending edges of colours placed side by side into one another in order to have a soft transition of tones. There isn't much layering here, more placing colours next to one another.

We will use Poppy Red, Scarlet Lake, Crimson Red, Crimson Lake, Process Red, Tuscan Red, Black Grape and Indanthrone Blue to add colour to the rest of the apples. Apply Poppy Red to the lightest areas. Use Scarlet Lake, Crimson Red and Crimson Lake for areas that turn into shadow. Add Tuscan Red, Black Grape and Indanthrone Blue to the dark shadowed areas between the apples and at their bases. Use the dark pink colour of Process Red for accent.

Add or readjust colours in any of the reflections drawn in Stage 1, then carefully blend their edges into the red colours you have just applied.

Complete the surface on which the apples sit by applying Luminance White to the lighter areas between the fruit, then add Cloud Blue and a little Luminance White around the shadows.

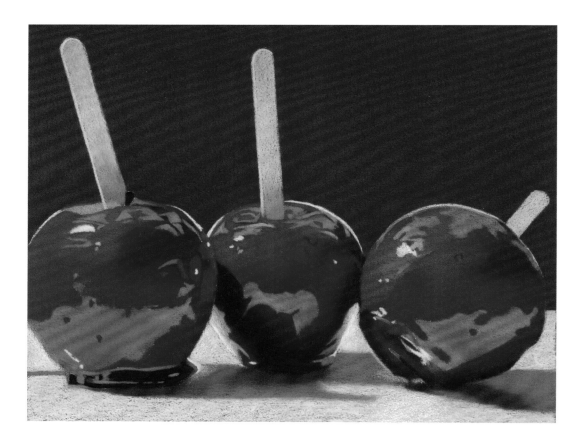

STAGE 3

All the colour is in place, so we can start adding the solvent. Dip your brush in solvent and lightly blot on a paper towel before applying it to the paper. You want the brush to be damp but not overly wet to avoid it creating a puddle on the paper. Lightly brush very small areas of colour, staying within areas of similar colour, and be careful not to brush colours into the white areas. Notice how the solvent begins to melt the pencil and make it move around like paint.

Lights and darks should be done separately and with a clean or separate brush. Take the same coloured pencil as the area you are working on and draw into the solvent area while it is still damp. This will build a bright and opaque layer of colour. The tip of the pencil may start to mush from the solvent, so clean it with a paper towel, then lightly wipe away any crumbs of colour with a soft brush.

Take the damp brush and go over each colour again, smoothing it out and blending it with the solvent. I sometimes blend with my fingertips too. If the solvent area is too wet to add more pencil, let it dry for a few minutes. Solvent stays moist for about ten minutes.

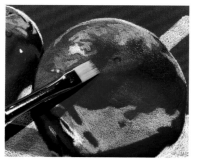

Add solvent to the drawing by lightly brushing areas of colour with a damp brush.

Blend the surface with solvent using two brushes for the light and dark areas or clean your brush well in between working the different areas. Notice how the Cloud Blue area is a little more difficult to get smooth, as you are blending a very light colour into the dark-toned paper surface. You can also add lighter colours over darker colours while the solvent is wet or after it has dried. For instance, I have put Crimson Lake over the darkest areas blended with Tuscan Red, Black Grape and Indanthrone to lighten them a little and give them a red glow.

Add a layer of Black Grape to the background, but don't worry about applying it evenly, as it will be covered with solvent in Stage 4. I chose a dark-toned background to make the apples stand out.

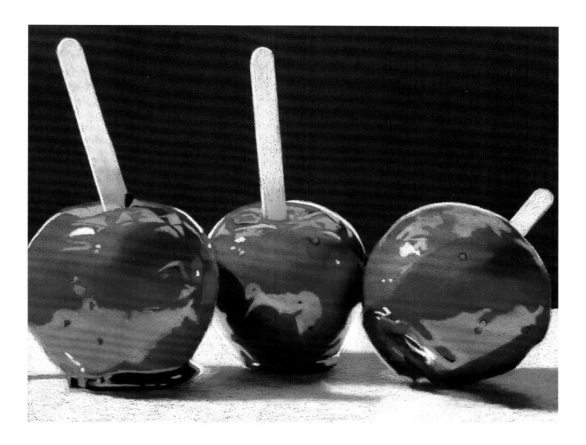

STAGE 4

Now you can add solvent to the background, working on small areas at a time with a flat brush (I like to use a ¼in soft flat brush for this), perhaps using a ½in brush to smooth larger areas. Apply solvent as you did in Stage 3, making sure the brush is damp but not overly wet. Use strokes in different directions to even out the background. After applying solvent to an area, add more Black Grape and smooth out again with the brush. If it gets too wet or pencil colour starts to move around, let it dry for a few minutes and go back over it. You can also add more solvent after the background is dry and rework it with the brush and the pencil.

To finish, accentuate the large reflections in the apples with an outline of Tuscan Red, then reapply any colours where needed.

Apply solvent to the background base colour, working small areas at a time. I have added more Black Grape pencil and am smoothing it out with the brush.

Glossary

BLEND To merge marks together smoothly.

BURNISH Blend layers until pencil mark is smooth and none of the paper surface is showing through.

CHROMA The intensity of a colour, how bright or dull it appears.

COMPOSITION The harmonious arrangement of the parts of a picture in relation to each other. It is how everything is arranged within the shape of paper you have chosen.

CONTOUR LINE Defines the outline or edges of a form as well as changes in planes within the form.

CONTRAST The use of light and dark tones or colours next to each other so that each will appear emphasised.

FIXATIVE A liquid spray similar to varnish that binds the pigment to the drawing surface for better preservation and to prevent smudging.

HATCHING Groups of small parallel marks, which produce the effect of tone or density in a drawing.

HIGHLIGHT The lightest tone in a composition, occurring on the most brightly lit parts.

HUE Pure pigment colour without black or white added.

JUXTAPOSE Placing two or more objects side by side with the intention of comparing or contrasting elements.

LAYERING Basic pencil technique that involves adding colours on top of one another using light pencil pressure.

NEGATIVE SPACE The space around a physical object (can also be described as the background).

PAPER STUMP A useful little tool that looks like a pencil without the graphite and is made completely of compressed paper. It is used to blend and smudge coloured pencils on the paper, similar to using your finger to smudge but more precise.

PERSPECTIVE Techniques used to create the illusion of depth and spacial recession in drawing and painting. Aerial or atmospheric perspective is the illusion of distance in landscapes or seascapes by diminishing in colour, tone and size.

PIGMENT Natural or chemical coloured substance used in the making of coloured drawing media, such as paint, dyes, inks, etc.

POSITIVE SPACE The physical space an object occupies.

SOLVENT A type of paint thinner used for thinning pigment in artistic applications. Odourless solvents are best to use.

STROKES Marks made with pencil, can vary in size, shape and width.

TONAL VALUE The light or dark of a colour used to render a realistic object.

UNDERPAINTING The initial layer of pigment applied to the surface which serves as a base for subsequent layers of pencil or paint.

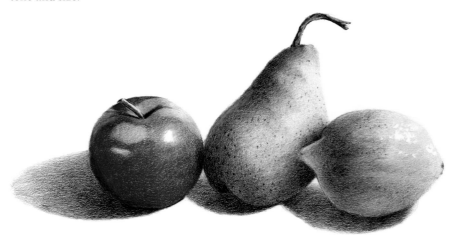

About the Author

Kendra Ferreira has a bachelor of fine arts from Massachusetts College of Art and Design, Boston. She is a signature member of the Colored Pencil Society of America and has also earned a second signature status from CPSA in exploratory mediums with coloured pencil. Kendra's work has been included in many national and international art exhibitions and she is a recipient of numerous awards for her work.

Kendra has enjoyed teaching adult and teen art classes for over twenty years. She is the mother of three grown sons and lives in Bristol, Rhode Island, USA with her husband Paul and small dog Bandit. Besides coloured pencil, her interests are travelling, skiing, hiking and cooking.

www.kjfdesign.com

Acknowledgements

I would like to thank GMC Publications and Dominique Page for giving me the opportunity to write this book. Thanks also to Sara Harper, Lisa Morris and Wayne Blades for their continued help and guidance with this project. I'm extremely grateful to my husband Paul for his understanding and patience as I wrote and illustrated the book, and to my family who have long lived with my passion for all things artistic. My thanks also to friends, artist colleagues and teachers for being a source of inspiration and learning. Last but not least, thank you to my past, present and future students for allowing me to share techniques and to learn through them.

Index

To place an order, contact:

GMC Publications Ltd
Castle Place, 166 High Street, Lewes, East Sussex
BN7 1XU, United Kingdom
Tel: +44 (0)1273 488005
www.gmcbooks.com